JAMES HAWES is the internationally bestselling author of *The Shortest History of England* and *The Shortest History of Germany*, as well as six novels (two of them filmed) and a book about Kafka. Before he became a writer, he was in charge of CADW excavations at Blaenavon Ironworks, now a UNESCO World Heritage site. He lives in Bath, and is Reader in Creative Writing at Oxford Brookes University.

ALSO BY JAMES HAWES

The Shortest History of England
The Shortest History of Germany
Englanders and Huns: The Culture-Clash which Led
to the First World War
Excavating Kafka
Rancid Aluminium
A White Merc with Fins
White Powder, Green Light
Speak for England

First published in Great Britain in 2022

Old Street Publishing, Notaries House, Exeter EX1 1AJ

www.oldstreetpublishing.co.uk

ISBN 978-1-913083-04-5

10 9 8 7 6 5 4 3 2 1

A CIP catalogue record for this title is available from
the British Library.

Printed and bound in Great Britain.

BRILLIANT ISLES

ART THAT MADE US

James Hawes

OLD STREET PUBLISHING

CONTENTS

'What are we? What the hell are we?
And what are we doing here?'
ANTONY GORMLEY

INTRODUCTION

A century ago, the British Empire comprised
a quarter of the world, so people were naturally fascinated by
the way it did things. Even the mighty Americans: in *The Great
Gatsby* (1925) the hero tries to make his murky New Money
respectable by speaking in a bizarrely 'British' way.

Well, goodbye to all that. We now rule nobody but ourselves,
and even who 'we' are is doubtful: if Scotland goes its own
way, Great Britain (1707) and hence the UK (1801) are history.
So you might think that what goes on in our heads would
nowadays be of little interest to the rest of the world.

Yet – Empire or not – our visions still play around the globe.
The diplomats know that our creativity is a vital part of our 'soft
power' but there's nothing soft about the part it plays in our
economic well-being. The creative industries pour more into
our national coffers than the cars we make, the planes we build,
the fuels we extract and the Life Sciences we do – *all put together*.
And they are growing faster.

The US diplomat, Dean Acheson, said that the British had
lost an Empire but failed to find a role. Perhaps we have found
one. No longer the workshop of the world, we have become
instead a great workshop of humanity's dreams.

But why are our dreams so potent? How is that what we
write, compose, build and otherwise create should have such
reach? It is because of our extraordinary past, which whispers
every day in our ears, whether we know it or not, and makes
us what we are. Our creative DNA is rooted in our strange,
fractured and still-unresolved history.

So where should we begin?

1. LIGHTS
IN THE DARKNESS

Spong Man

Y Gododdin

The Staffordshire Hoard

Aberlemno Stones

The Lindisfarne Gospels

Beowulf

Anglo-Saxon Mappa Mundi

The Bayeux Tapestry

Stories don't begin at the beginning.

There's always a 'set-up', a state of things which could go on forever. Then something crashes in from outside – Christians call it 'the Word', screenwriters call it the 'inciting incident', astrophysicists call it 'the God particle' – and everything changes forever.

Our 'set-up' is that nothing unusual occurred in these islands between the last great Ice Age and about 450 AD. Throughout the Palaeolithic, the Mesolithic, the Neolithic, the Bronze Age and the Iron Age, what happened here was basically the same as what happened in the rest of Western Europe. Any small differences can be put down to the simple logistics of us being off the edge of the Continent, meaning that innovations arrived here a bit later, hence more fully-formed.

This didn't change even with the coming of the Roman Empire and written history. 'Roman Britain' was just that – the cultural and political outer edge of a vast monoculture spanning all Western Europe and the Mediterranean, though it barely touched Ireland.

Fittingly, the real story of culture in these islands, of how it has constantly had to react to radical changes, begins with the greatest shift in European history: the Fall of the Roman Empire. It was only then that something really happened here, something that would make life on these islands – and therefore the art produced here – unique.

Spong Man

Unknown artist | ca. 420 AD | Norwich Castle Museum

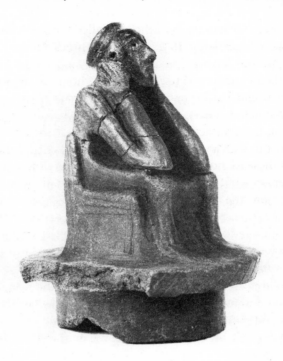

He's on a chair that is maybe a bit like a throne. He has a place in the world – but he is confronting a place where none of that has meaning anymore.

ANTONY GORMLEY

The moment we see this, we know it's some ancestor of Rodin's 'The Thinker'. When we learn that it stopped up a cremation urn, it's hard not to see some god of the dead, contemplating eternity. One Cambridge scholar has argued that he may be none other than Woden/Odin himself. For this is pagan Germanic art – but not from Germany.

Spong Man, from Norfolk, is the first known three-

dimensional, figurative art created here by the people who migrated from Germany into late Roman Britannia. They came as mercenaries, and the first tribe to come in numbers were the Saxons. By the time Spong Man was made, the fortified coast of south-eastern Britannia was officially called the *litoris Saxonum* – the Saxon Shore – and to this day every other culture here calls the English the Saxons (*Saeson/Sassenach/Sasanach*).

Germanic warriors were a common sight in the late Roman Empire: by 400 AD, 'Roman' armies were largely made up of them. When the Western Empire fell in 476 AD, such warriors took over, from modern-day France to North Africa. It happened here too, but with a vital difference that would change the whole story of these islands, indeed of the world. That difference was the Channel – not as a barrier, but as a great sea-road.

Elsewhere, the new rulers stayed a Germanic warrior elite. Their own tribes never joined them: infants, nursing mothers, and the elderly could not survive great land-treks across the ravaged former Empire. So the new elites married local women from the old elites. Since language and culture are transmitted by mothers, a sub-Roman world endured all over Western Europe. The pagan Germanic Franks, old allies of the Saxons, soon turned into the Christian, sort-of-Latin-speaking French.

Here, though, the pagan Germans, already manning the Channel forts, could easily invite their entire clans to cross by ship in a day or two, women, culture and all. The early sources speak clearly of messages home to Germania and successive waves of migrants. So, in lowland Britannia, and there alone, the new elite stayed pagan and kept their own language.

This is the real beginning of our story, the original parting of the ways from Western Europe. It is why Woden, god of the obscure tribes who made Spong Man, is still unthinkingly honoured around the world, every time someone says Wednesday. And it was the birth of a tension between the English and non-English on these islands that still haunts us all.

EXPLORE FURTHER | Silver amuletic pendant, poss. Woden (7th c. AD; Brit. Mus; 2001,0902.1) • 'The Thinker' by Auguste Rodin (1904; Musée Rodin) • 'Another Place' by Antony Gormley (1997; Crosby Beach)

Y Gododdin

Aneirin (attrib.) | ca. 7th c.

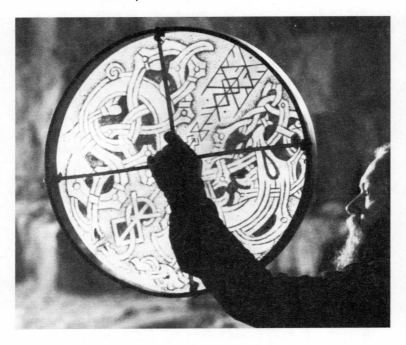

The fact that a story like this, a poem that was probably spoken for the first time 1,400 years ago, is still here – that I can stand here and say those words and be in that chain – is a miracle. It was about their identity, about who they were, their very existence.

MICHAEL SHEEN

The further the English (as in, German) newcomers advanced from their bridgeheads, the stiffer grew the resistance from the Romano-British, whom the English called (and still call) the *Weahlas*. At times deals were cut: one early Saxon king had at his command an elite cavalry unit, the *cyninges horsweahl*, which translates handily as 'The King's Welsh Horse'. Yet though modern nationalism was still centuries away, some of the

Romano-British felt they were battling these illiterate pagans not just for local power or status, but for cultural survival. That feeling, then as now, is the most potent recruiter.

Y Gododdin, written around 600 AD and preserved in a 13th-century manuscript, where it's ascribed to the poet Aneirin, lives on in a very different way from *The Battle of Maldon*, a similar Anglo-Saxon tale of warriors who die heroically resisting an invader. English speakers today would need months of training before attempting to decode *The Battle of Maldon*, but any modern Welsh-speaker can make some sense of this tale about doomed young warriors from south-western Scotland, which was then still joined with Cumbria, Wales and Cornwall in a western continuum.

The fighters who perished in the vain attempt to resist the Northumbrian Anglo-Saxon tide (after a whole year of solid feasting, according to the bard) have no physical monument, nor is it even agreed where they died. Yet these unknown soldiers of the Dark Ages are remembered in Wales to this day, thanks to the power of art. For glorious though the deed may be, it is creative artists who mould it and confer immortality.

> *a boy with a man's heart,*
> *on fire for the front*
> *restless for war...*
> *as the singer of this song,*
> *I lay no blame*
> *but only praise for him,*
> *sooner gone to the battlefield than to his marriage bed,*
> *sooner carrion for the crow,*
> *sooner flesh to feed the raven...*

Meanwhile, Northumbria extended its power northwards to Edinburgh and beyond, bidding for supremacy right across Britain – until it ran into an unlikely and deadly alliance.

EXPLORE FURTHER | 'The Battle of Maldon', poem, author unknown (10th c. AD?) • Book of Aneirin, various poets (13th-c. copy of 9th-c. original; Nat. Library of Wales) • 'The Charge of the Light Brigade', poem by Alfred Tennyson (1854)

The Staffordshire Hoard

Unknown artists | 570–650 AD

Birmingham Museum and Art Gallery

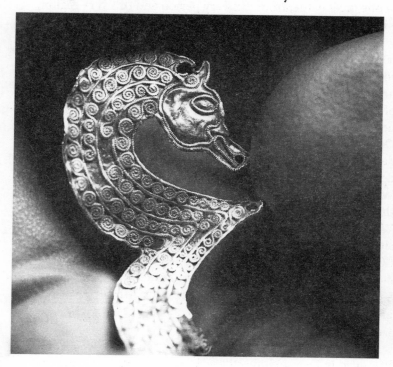

Museums have approached modern-day jewellers and asked, *Can you do this?* And some of the best jewellers in the world have said, *No, we just can't*. We don't know how they did it.

<div align="right">

HEATHER PULLIAM

</div>

This is the greatest hoard of Anglo-Saxon gold ever found, and the most mysterious. It consists of priceless weapons, armour and warriors' accoutrements, some of them with obvious Christian elements, which were *deliberately destroyed before burial*. One extraordinary object, a mighty steel-and-gold

plumed helmet which must have belonged to a warrior of the highest status, was smashed into over 1000 pieces. Everything points to the ceremonial aftermath of a triumph over enemies who were far more than just local rivals. Fascinatingly, we know of one great battle, from this very period and this very region, which fits the bill.

Oswald of Northumberland (whose recent forebears had defeated the warriors of *Y Gododdin*) was now driving southwards in his quest to dominate the island. But in 642 AD he came up against the last pagan English ruler, Penda of Mercia, a warlord who had already killed three rival neighbouring English kings and had an ace up his sleeve. On Penda's western border, the Welsh still held modern-day Shropshire and Cheshire: though Christians, they were determined to keep their own, Celtic rites. Despite worshipping Woden, not Christ, Penda somehow forged an alliance with them. Together, pagan English Mercians and Christian Welshmen smashed the Christian English Northumbrians. The site of the battle is uncertain. Some have suggested Oswestry ('Oswald's tree') in Shropshire, but most experts agree that closer to the Northumbrian-Mercian border is more likely. The Staffordshire Hoard is in the right place at the right time, and grand enough to be the relic of this no-prisoners-taken, three-way culture-clash.

Whether or not that great helmet, so deliberately pulverised, belonged to Oswald himself, the Hoard is a glorious, vital twist in our creative story. For it shows that though this was indeed a Dark Age in terms of written records, and an era of deadly rivalries and baffling alliances, creativity of the highest order didn't just survive, but positively flourished. Whatever else art in these islands needs, it doesn't seem to need peace and tranquillity. Which was a good thing in the 6th and 7th centuries, for peace was in short supply not just on the western limit of the English advance, but on the northern one too.

EXPLORE FURTHER | Norrie's Law Hoard (6th c. AD; Nat. Mus. of Scotland) • West Yorkshire Hoard (7th–10th c. AD; Leeds City Mus.) • Watlington Hoard (870 AD; Ashmolean Mus.)

Aberlemno Stones

Unknown artists | ca. 6th–9th c. | Aberlemno

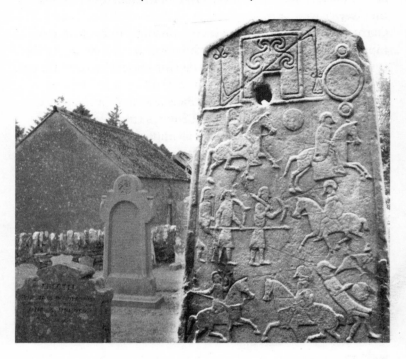

It is possible that it portrays a battle in 685 AD, around a century before it was made – a decisive battle in holding back the English tide from central and eastern Scotland.

GARETH WILLIAMS

How are we to understand this strange mixture of heroic and Christian art? Of all people of these islands in the Dark Ages, the Picts are the most mysterious. Modern scholars can't even agree on what language they spoke, though most believe it was the northernmost variant of Brythonic (the root of modern Welsh, Cornish and Breton). They were named by Roman writers, whose term *'picti'* have meant 'painted people',

and described a powerful barbarian tribe or confederation of tribes who harried Romano-British civilisation from beyond Hadrian's Wall. However, in the 5th century, the Picts themselves were invaded – not by the Saxons fresh from Germany, but by the Scots who (confusingly to us, with our modern ideas of nationalities) came over from Ireland. By the seventh century, a Gaelic-speaking elite had taken over, though English sources still call them 'the Picts'.

Under this new leadership, the Picts in 685 AD won a great victory over the Northumbrians at Dun Nechtain (to the English, Nechtansmere). This was so important a battle – the Northumbrian king himself, Ecgfrith, was among the dead – that it is recorded in unusual detail by both Anglo-Saxon and Celtic sources. Most experts agree that the location was modern Dunnichen, just a few miles from the Aberlemno stones.

Still, we can't prove it. And even if we could, we couldn't prove that the stones are anything to do with the battle. That's what makes the Dark Ages essentially a period of archaeology, not of history. As with all archaeology, the absence of records means we need to use our imagination.

We still make monuments to our fallen heroes, often employing our greatest artists to create them, and on certain days we gather about them to recall the glorious dead. If, as the sources suggest, the battle of 685 was a turning-point in our island history – the fight that ended Northumbria's supremacy and ensured the survival of the lands beyond Hadrian's Wall as a separate entity (if not a Pictish one) – people might well have gathered there two or three generations later, to hear again the stories that had been handed down, and to commemorate the day with the help of their finest artists.

Perhaps, to understand the Aberlemno stones, we just have to imagine a modern version, and recall that all lasting art, though produced by individual minds and hands, has some communal echo. That is certainly true of our next artefact.

EXPLORE FURTHER | Lion Hunt of Ashurbanipal (645–635 BC; British Museum) • The Trenecatus Stone (6th c. AD; Nat. Mus. of Wales) • National Memorial Arboretum (1997; Alrewas, Staffs.)

The Lindisfarne Gospels

Eadfrith | ca. 8th c. | British Library

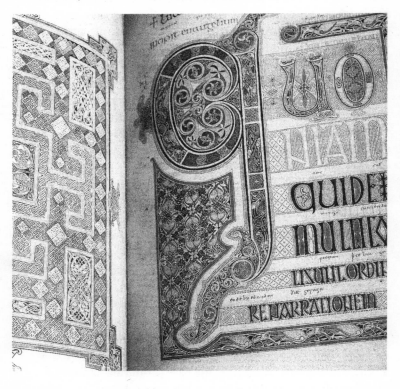

Heaven was portrayed as a place of jewelled sumptuousness, so if you were trying to give people in this life a glimpse of what lies beyond, you would build magnificently, you would paint richly, you would ornament gorgeously, because you were giving people a sense of the heaven that awaited them.

REV. RICHARD COLES

Northumbrian churchmen of the 8th century were the spiritual wing of a heroic, martial culture. While earthly warriors yearned, like Beowulf, for *lof* (kudos), priests saw

themselves as shock-troops of the Roman Church, fighting devils, English pagans and Celtic Christians alike for the ultimate glory of the next world. They showed their heroism by choosing to live and work monastically in remote and storm-tossed locations shunned by ordinary farming folk. The most extreme – and hence, the holiest – was the monastery at Lindisfarne. Here, in around 721 AD, a Bishop called Eadfrith created one of the most glorious books in the history of all Europe, an extraordinary synthesis of the Latin word of God and local Anglo-Celtic art-forms.

This mixture of styles was quite deliberate, for here, as so often, art had a hidden political mission. Despite the great defeat of 685 AD (p.11), the Kingdom of Northumbria still stretched north to beyond modern Edinburgh. This meant that it had Pictish and Gaelic subjects, as well as English. How was a churchman, fighting against both pagans and Celtic Christians, best to spread his message of obedience to Rome in this ethnically and linguistically complex realm? Over a century before, Pope Gregory the Great, planning the conversion of the English, had laid down the plan of action, advising St Augustine that 'places are to be loved for the sake of the good things in them'. In other words, missionaries should enlist whatever rites worked for local populations. Eadfrith's great new Bible did exactly that.

By using the blend of creative styles known to later historians as *Hiberno-Saxon*, Eadfrith made sure that wherever in Northumbria his mighty new book was ceremonially revealed, on high days and holy days, his awestruck flock (who were, of course, completely illiterate) would see images that were splendidly, magnificently new – yet also, at some level, familiar. *The Lindisfarne Gospels* owe their glorious uniqueness to the fact that they were created for a multicultural audience.

And it was yet another coming-together of different cultures on this island that gives our next work its meaning and its strange power.

EXPLORE FURTHER | *Book of Deer*, earliest Scottish ms (ca. 850 AD; Cambridge Univ. Lib.) • *Black Book of Camarthen*, earliest Welsh ms (13th c.; Nat. Lib. Wales) • *Act of St Takla of Haymanot*, Coptic illuminated ms (1700–1750; Brit. Lib.)

Beowulf

Unknown writer | ca. 10th–11th c.

There are 30,000 surviving lines of old English poetry, and yet there is only one poem that we ever remember – *Beowulf*.

CLARE LEES

Remember it, yes – but understand?

> *Hwæt! We Gardena in geardagum,*
> *þeodcyninga, þrym gefrunon,*

Our 'national epic' might as well be in a foreign language. Even in its own day there was something curious about this

story: though it's written in Anglo-Saxon, all the action happens in southern Scandinavia. It seems that the English of the 9th century retained a sort of early-medieval dual citizenship in the lands across the North Sea.

A dual mental world, too. The scribes who set down this much older, oral legend were undoubtedly Christians, yet there's no mistaking the enthusiasm when they describe pagan, heroic warrior values. Indeed, compared to the power of those sections, the attempts to bolt on a Christian moral world-view (stressing good deeds as the way to heaven, and so on) often feel like half-hearted asides. Look at the great description of Beowulf's funeral pyre. There's no sign of a Christian God, and the church of the day strictly forbade cremation, but there was no choice: the story said Beowulf's body was burned, so Beowulf's body burned. Just as Beowulf himself hopelessly fights the dragon, the scribe hopelessly fights the power of his ancient tale. It's like reading a modern writer trying to re-tell a famous story and having to keep moments which just can't be left out or changed, no matter how culturally unacceptable they now are.

And perhaps *Beowulf* owes its survival precisely to this uneasy blend of pagan and Christian, which made it the right story for the political times. In 868 AD, England was split in two between Christian Wessex and the pagan, Viking-ruled Danelaw. Alfred the Great and his descendants spent the next century and a half trying (unsuccessfully) to unite these two nations and cultures. *Beowulf* was the perfect tale for this drive. Written in English but set in Scandinavia. A tale of pagan heroic values with a modern Christian gloss that didn't change the vital, ancient elements. The ideal story, in fact, to persuade a pagan Danish warlord that he could convert and become a subject of Wessex without giving up what really mattered of his own world.

With *Beowulf*, as so often in our history, the fascinating strangeness of our art grows out of its conscious or unconscious quest to bring together rival cultures.

EXPLORE FURTHER | *Hero Myths and Legends of the British Race*, illust. John Henry Frederick Bacon (1910) • *Beowulf*, translated by Seamus Heaney (1999) • 'Beowulf', film, dir. Robert Zemeckis (2007)

Anglo-Saxon Mappa Mundi

Unknown artist | ca. 11th c. | British Library

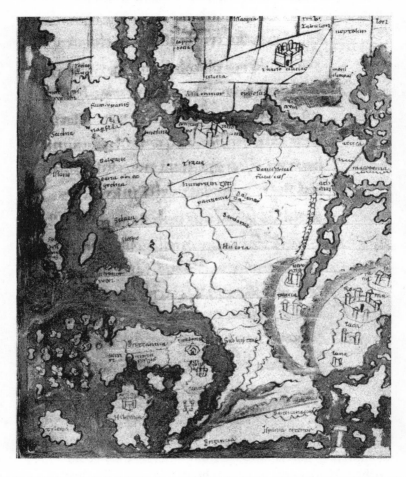

Nobody would use this map to get to Rome or Jerusalem. But if you drew a map, you'd probably draw your own neighbourhood pretty well, then everything else would be a bit thinly imagined. Yet it would tell me a great deal *about you*.

HEATHER PULLIAM

The *Mappa Mundi* is a window onto the mental world of 11th-century England. The attempt by Wessex to rule the Viking-settled lands of the North and East by diplomacy, conquest or (in 1002, under Aethelred the Unready) state-sponsored mass-murder, had backfired. In 1014, those areas rose to greet as liberators Swein Forkbeard, King of Denmark, and his son, Cnut, when they invaded. Swein was proclaimed king, but died before he could be crowned. Cnut finished the job in 1016. For the next 25 years, the elite of England spoke Danish. We still belonged to Christendom, but were now on the edge of it, part of a sea-going Danish empire that had only just become Christianised. That's why the *Mappa Mundi*, the first surviving halfway realistic map of these islands, shows Scandinavia in greater detail than any other map would for centuries: what really mattered to people here in the 11th century was understanding their new place in the world.

Danish conquest, though, was merely the prelude. Across the Channel, other warlords of Viking descent, thoroughly *au fait* with seaborne invasions, were watching. They saw that wealthy but disunited England really could be won and ruled. These particular Vikings had adopted the French language and culture of chivalry, together with its cutting-edge military tactics. In 1066, their leader, Duke William of Normandy, was ready to make his play.

Once again, England was doomed to be unique in Western Europe. Here, and only here, a vibrant, internationally-recognised culture, with its own art and literature, was about to be wiped out. England was to be dragged back into the European mainstream – but by a foreign ruling class who spoke an entirely different language from the common people.

The consequences of 1066 echo to this day in the head of every English-speaker on Earth, and have defined the wars and politics of these islands ever since. And of course, from the start, the victors wrote our history – or indeed, embroidered it.

EXPLORE FURTHER | Map of the British Isles by Matthew Paris (1250; Brit. Lib.) • The Gough Map (ca.1300; Bodleian Lib.) • Map of Nowhere by Grayson Perry, drawing (2007; Gov't Art Collection)

The Bayeux Tapestry

Unknown artists | 11th c. | Bayeux, Normandy

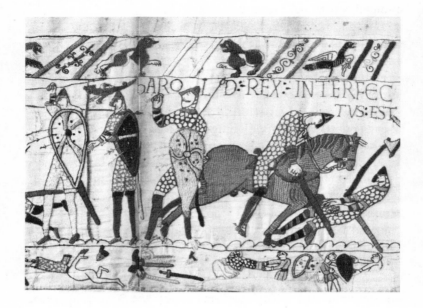

The Bayeux Tapestry immortalises one view of a very contentious recent event. The Normans have conquered England, and it says they did so by right of God through trial by battle. Its genius lies in telling the story almost entirely in visual terms. You realise what a challenge this was if you think for a second, *'How would I describe the events of the last two to three years in pictorial terms?'*

RICHARD GAMESON

This miraculous survival of dyed wool threads stitched onto linen asks endless questions. To take the most obvious: is the man with the arrow in his eye really Harold at all? Isn't he more likely to be the man fighting on foot with an enormous axe (as the Anglo-Scandinavian elite did), cut down directly beneath the

words 'was killed' – '*interfectus est*' – by one of William's mounted fighters (cavalry was the recent, battle-winning innovation in European warfare) who has broken through the 'shield wall' protecting the English leader?

But this entertaining question is dwarfed by the truly profound issues the tapestry raises. For it doesn't just record the completely one-sided politics of England after the Conquest, encapsulating the seismic shift that had just taken place in the history of these islands. It asks timeless questions, about who creates art, to whom it ever truly belongs and by what right. It even questions who 'we' today really are.

The tapestry was almost certainly made by English women, in England: their needlework was famed throughout Europe as *Opus Anglicanum* ('the work of the English'). But it was commissioned by one of the mightiest of the new elite, the Conqueror's half-brother, Bishop Odo, in order to nail down the Normans' story of how they came to rule over the people who made it. So is it English art? Or Norman? Or perhaps Anglo-Norman (even if under a very unequal deal)? Can it be truly English at all, given that it records and justifies the subjection of all English-speakers under a new French-speaking elite? But how can it not be English if it was made in England by English-speaking people? Should it be kept in England, not France? To whom does this ancient art, or any ancient art, truly belong? To the nameless people who actually made it? To the mighty lord who commissioned it? To the people whose story it tells? To whoever happens to own it now?

The Bayeux Tapestry demolishes any notion that we are formed either by our genetic inheritance or by a modern sense of national identity. It insists that we today – the 'we' who rightly see the Bayeux Tapestry as part of 'our' story – are, by language, culture and history, neither English nor Norman or even Anglo-Norman but… well, whatever it is we have since become, and presently are, and are still becoming.

EXPLORE FURTHER | Devonshire Hunting Tapestries (1430–1450; V&A) • Holy Grail Tapestries by E. Burne Jones & W. Morris (1899; various) • The Overlord Embroidery, designed by S. Lawrence (1974; D-Day Mus., Portsmouth)

2. REVOLUTION
OF THE DEAD

Any English person who only spoke English

was now a second-class citizen, looking after the cows, swine and chickens while their betters feasted on beef, pork and poultry. It may at first seem far-fetched, yet that class-divide in language is still alive and well today. Here are two sentences:

> We have profound issues to discuss in examining our national story, so we are obliged to employ vocabulary derived entirely from French.

> We have deep things to talk about in looking at the tale of our land, so we must use words which all come from Anglo-Saxon.

They are both perfectly correct English. But the first sounds like an expert, while the second just sounds weird. A millennium after the Conquest, we still assume that powerful folk talk French-like.

The split was so deep that many centuries later, the English even took it across the Atlantic: all the bad guys in Hollywood speak Frenchified English ('Resistance is futile, you will be assimilated'), while the good guys speak Anglo-Saxon ('The hell we will! Shields up, open fire, hard a-starboard').

Yet there was never a national English uprising. England's new French-speaking rulers were so secure that they soon had their eye on Wales, Scotland and Ireland as well. And they might have stayed in the saddle, on their high horses, talking their fancy foreign, looking down their noses at us – those images are locked into the language – but for a terrible disease carried along the Silk Road from China.

Pearl

Gawain poet (attrib.) | 14th c.

When we talk about writing as consolation, we think in therapeutic terms, but it can be more about imposing order on an insensate and bewildering world, a world that cannot be controlled.

SIMON ARMITAGE

Pearl tells the tale of a master jeweller who has lost a pearl, which turns out to be, in reality, his dead child. The poem's original listeners knew all about the need to process loss and

trauma. They were still going through the greatest pandemic in European history, the Black Death, which arrived in England in 1348 and recurred every 5 to 10 years until the 1380s.

By the time *Pearl* was composed, the population of these islands had virtually been halved. The survivors were desperate for reassurance that God was still in his heaven. Perhaps this explains the extraordinarily complex structure of the poem. However shattering the poet's loss, everything comes around, everything is linked, everything unfolds to a strict, secret pattern. *Pearl* has an astoundingly intricate structure, founded on the symbolism of numbers, or 'numerology'. The poem has a total of 1,212 lines and each of its stanzas is 12 lines long. This relates to the heavenly Jerusalem, said to be 12 furlongs long, and to its 12 gates, each of which are set with pearls.

So much for artistic-religious consolation. But in England, the Black Death had a unique effect on the earthly social order. Here, and here alone, all native-speakers had long been second-class citizens in their own land, and they knew it.

> Unless a man knows French, men think him of little account…
> I think that England is the only country in the world that doesn't hold onto its own language.
>
> ROBERT OF GLOUCESTER, C.1290

The Black Death blew that apart. The plague left property untouched – but even the richest agricultural estate was worthless if the landlord couldn't find enough labourers to work it. The lucky survivors among the English-speaking peasantry had, at last, a real lever in their dealings with the French-speaking elite. They demanded, and obtained, unheard-of wages.

Death had changed the social game. And as ever, culture responded: creative English people began to fill the late 14th century ether with hidden murmurs of rebellion – sometimes, in the most unlikely places.

EXPLORE FURTHER | *Sir Gawain and the Green Knight*, narrative poem (late 14th c.) • 'Holy Sonnet 17' by John Donne (1617) • 'Crossing the Bar' by Alfred Tennyson, poem (1889)

Lincoln Misericords

Unkown artists | ca. 1370 | Lincoln Cathedral

Here is a place for storytelling, for delight, for cheekiness – and a little bit of push-back.

CLARE LEES

A strange freedom seems to have been granted to craftsmen when it came to misericords. These ledges beneath hinged seats in the choir, on which tired priests could discreetly lean their behinds while apparently standing, are often carved with pagan-looking images. And no creative work is neutral; every creator has an agenda, public or secret. It is the hidden agenda that makes this particular misericord so fascinating.

Why did the carver choose to show the moment when a knight, undoubtedly rich and of high birth, is brought low by that most plebeian of weapons, an arrow (not for nothing the weapon

of Robin Hood)? Here he is, in top-of-the-range aristocratic armour, toppling forward, mortally wounded but still clutching his broken lance under his arm, as his gorgeously-accoutred charger stumbles. The carver is a master of his trade: an extraordinary command of detail is visible in the knight's mail-and-plate armour, the horse's trappings, the dynamic movement of the rider and his mount, both heading for a fall.

We need to understand exactly where and when this small masterpiece of subversion was created. The Englishman who carved it was employed in a great cathedral which, along with neighbouring Lincoln Castle, was one of the most important bastions of elite power outside London. Every day, at work, he would have heard his social betters speaking French or Latin to one another. But men like him, who were often much freer after the Black Death, were growing sick of it. Just ten years later, the Peasants' Revolt of 1381 would break out. Rebellious English peasants would rampage through London, burning every French and Latin document they could find, even killing the Archbishop of Canterbury and (according to one account) playing football with his head.

When we know what's coming, and coming very soon, the meaning of the carving snaps into focus. This aristocratic warrior hasn't been hit in the front while charging some open enemy. He's been shot in the back, exactly where the lacing of his armour leaves a tiny but fatal gap. This isn't death in battle; it's assassination from behind, by a skilled archer who knows just where to shoot.

Nobody in the 1370s could have looked at this picture, hidden away as it was under the backside of a priest, without understanding it as a secret message to the ruling order in England: *watch your backs*.

This is the radically new background against which, after centuries of being a second-class language, English is finally reborn in literature fit for the court itself.

EXPLORE FURTHER | Misericords (14th c.; Chichester Cathedral) • Wall graffiti (14th c.; Church of St Mary's, Ashwell) • The Mooning Man, gargoyle (14th c.; Church of All Saints, Easton-on-the-Hill)

The Wife of Bath's Prologue

Geoffrey Chaucer | ca. 1390

Something striking happens in the second half of the 14th century, when someone like Chaucer, who would certainly have started out writing in French, begins writing poetry for the court, for the highest magnates in the land, *in English*. What's so important about this is that now everyone can read it. This is before printing, so all books are incredibly expensive, but now you only need one copy – and one person who can read in a village – and that one person can take this one copy of a work in English, and read it out in the pub or the village square for everybody to hear and understand.

LAURA ASHE

Geoffrey Chaucer (ca. 1340–1400) was such a court insider that his wife was a lady-in-waiting to the Queen herself. A generation before, any English writer in his place would have used French. But when Chaucer began in around 1387 to write a brand-new set of linked tales to entertain the court, he chose the native language. Not only that, almost all his characters were from the everyday world of late 14th-century England.

For the first time since the Conquest, English people high and low could enjoy the same tales, in the same language, about people they would have recognised in daily life. The most memorable is Alyson, the Wife of Bath, the earliest real female character in our literature: sexually uninhibited, speaking as she finds, and upwardly mobile thanks to inheritances from the five husbands she has nagged and shagged to death. With her transactional attitude to bedroom dealings, her material desires, her statement clothes and her would-be posh manners – Chaucer tells us she has learned French, but badly – she cuts a strikingly modern figure.

> *My Lords, since when I was about twelve years old,*
> *thanks be to God, Eternal evermore,*
> *Five husbands have I had at the church door...*
> *Bedtime above all, was their misfortune...*
> *I never would abide in bed with them if hands began to slide*
> *Until they had promised ransom, paid a fee*
> *And then I would let them do their nicety...*

Yet there are times when comedy just isn't enough. Chaucer might have hinted at the darkness behind his humour, but far from the court, a very different sort of early English literature was being created – and it would soon be quoted by men determined to put the secret threat of the Lincoln misericord into bloody practice.

EXPLORE FURTHER | Chaucer Monument (16th c.; Westminster Abbey) • *Moll Flanders* by Daniel Defoe, novel (1722) • 'Canterbury Tales', BBC TV adaptation (2003)

The Vision of Piers Plowman

William Langland | 1367–90

Piers Plowman go to his work... Now right and might, will and skill: God speed ... *now is time*

JOHN BALL, RADICAL PREACHER (1381)

The Vision of Piers Plowman, a poem by a Midlands cleric called William Langland, tells the story of a character named Will, who falls asleep on the Malvern Hills and has a vision of a corrupt world in need of drastic reform. Unlike Chaucer's *Canterbury Tales*, it's extremely hard to read today, and not just because of the older-fashioned western Middle English. Even readers who can get past that hurdle will soon be lost in the dense forest of medieval Catholic religious allusion and imagery, whose twisting pathways we have long forgotten.

Our ancestors, though, knew all these tales and images. But they also lived in a world where storytelling was strictly

controlled: any version of things that didn't agree with orthodoxy, and that publicly criticised the authorities, was forbidden and quite possibly fatal. So they were used to listening very carefully, ready to detect any sign of secret rebellion. As they heard *Piers Plowman* being read aloud, they would have recognised that here, however carefully disguised as a fantastic dream, was a timely vision of a broken, corrupt society, punished by God with the plague.

It was radical enough that this poem discussed and explained, in plain English, the most profound religious mysteries, which had for centuries been hedged about in priestly Latin, impossible for the uneducated to penetrate. But it went further than that: when the first listeners heard Piers, the simple plowman, actually debating with a knight, and *correcting him*, they would have sat bolt upright. And no doubt they would have nudged one another in delight when they heard (in the earliest surviving reference to him) the name of Robin Hood.

The poet tells us that French-speakers and the most prosperous Englishmen have a taste for French rhyming poetry, but that *his* readers prefer 'the rhymes of Robin Hood'. Clearly, Robin, robber of the rich, hero of the poor, hiding out in his ancient, impenetrable woodland fortress, was already a well-loved character in the underground story-telling of the English-speaking lower orders. And now here he was, being openly named in an actual, written book!

The Vision of Piers Plowman evidently hit a great nerve of the day, for within a few years of its appearing, in an age when word of mouth was the only word there was, the hero had become an icon for ordinary Englishmen who were ready to do more than listen, and to heed the preacher John Ball's call: '*Piers Plowman go to his work.*'

The stage was set for one of the most extraordinary days in English history.

EXPLORE FURTHER | *Chronicles* by J. Froissart (14th c.) • 'After the Uprising' by Robert Koenig, sculpture (2006; Wat Tyler Country Park, Pilsea) • 'Fair Field' by Tom Chivers, play & website inspired by *Piers Plowman* (2017; thisfairfield.com)

Westminster Portrait of Richard II

Gilbert Prince (attrib.) | ca. 1395 | Westminster Abbey

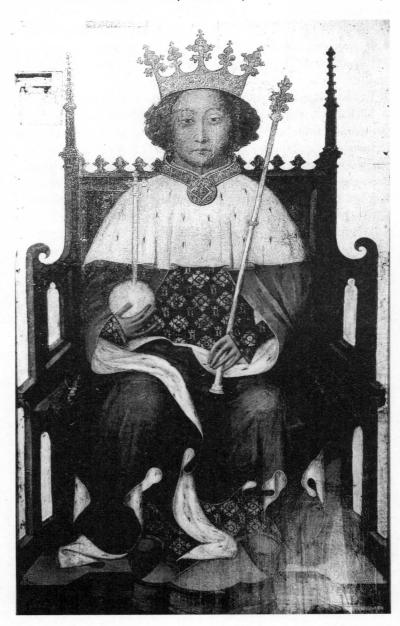

First impressions are of a religious icon. All the props, the crosses, the layers and layers of symbols reinforce this notion of him being a ruler by divine right. You'd almost think this was God.

CLARE LEES

R ichard II was the first living English king to be painted. That doesn't mean he intended to reveal his individual personality. On the contrary, he was using art to make a radically new statement about the position of royalty in England. This life-size portrait, painted on oak boards using gilding and egg-based flesh pigments, usually attributed to Richard's court painter, Gilbert Prince, is clearly designed to give the impression of almost godlike power.

We might imagine that this was a normal idea for medieval kings, but it was nothing of the sort. Even Richard's most ferocious ancestor, Edward I, had understood that to rule England, he must parley with his aristocracy, in Parliament (so named for that very reason). The 'Westminster Portrait' is the artistic expression of Richard's attempt to break this deal.

Richard's conviction that he was chosen by God to rule was surely born during the Peasants' Revolt of 1381. Only 14 years old, he had been forced to confront a vast and murderous mob that had only just beheaded the Archbishop of Canterbury himself. Somehow sensing that what the rebels really wanted wasn't a revolution but – for the first time in over 300 years – an English-speaking king, Richard took command. Alone, he rode forward to address them in English, promising to be 'their captain' and calling them 'gentlemen'. Astonished and delighted, the peasants cheered him, and disbanded.

You can hardly blame Richard for thinking he was special. Just how special is made clear by our next exhibit.

EXPLORE FURTHER | King Charles I by A. van Dyck (1635–6; Nat. Portrait Gallery) • Queen Victoria by Alexander Bassano, photo. (1882; Royal Collection Trust) • Vladimir Putin by Platon, photo. (2007; platonphoto.com)

The Wilton Diptych

Unknown artist | 1395–1399 | National Gallery

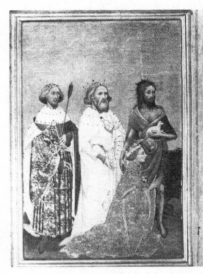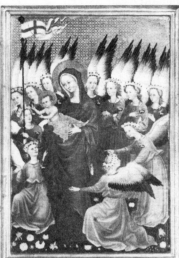

There seems to be some sort of transaction going on. This picture is about the relationship between the king of England, the court of Heaven and, of course, England itself.

GABRIELE FINALDI

'Transaction' is the right word. Medieval people understood every little detail of stories told in the visual arts. The Wilton Diptych, foldable and thus portable, enabling it to be carried by Richard on his travels and used in his church ceremonies, is almost a legal document in pictures.

In the left panel, Richard kneels for a sacred introduction. His sponsors are St John himself – and, remarkably, two Anglo-Saxon kings, St Edmund the Martyr and Edward the Confessor, whose supposed coat of arms Richard adopted in 1395. Richard, who in 1381 had become the first king to address his common subjects in English for over 300 years, is sending a populist

message: his right to the throne goes back even beyond the Norman Conquest.

In the second panel, the Virgin Mary accepts the banner of England while a squad of angels watch on – all wearing Richard's personal badge, the White Hart. The deal is clear: Richard, the rightful king of England, is giving the country into the protection of Mary in exchange for the backing of her angels.

The angels, bearing Richard's emblem of the White Hart.

In reality, Richard maintained his power by playing on the ancient North-South divide: in 1398, at Nottingham, he declared that if the 'men of Londoun and of xvii shires lyying about' didn't obey him, he would 'destroie thaym.' The following year, he seized the vast Duchy of Lancaster from his cousin, Henry Bolingbroke. Richard had broken the medieval power-deal, and in 1399, Bolingbroke was able to usurp him, becoming Henry IV – the first sovereign since 1066 to accept the Crown in English.

The ground was shifting. A country that for three centuries had been in thrall to a French-speaking elite was finding itself again. It is surely no coincidence that one woman in Norwich now claimed she was getting direct revelations from God, in English, bypassing the hierarchy of the Church.

EXPLORE FURTHER | The Ditchley Portrait (ca. 1592; National Portrait Gallery)
• *Richard II* and *Henry IV Pts 1 & 2* by William Shakespeare, plays (1595–99)
• Banqueting House Ceiling by Rubens, painting (1636; Whitehall, London)

Revelations of Divine Love

Julian of Norwich | ca. 1373

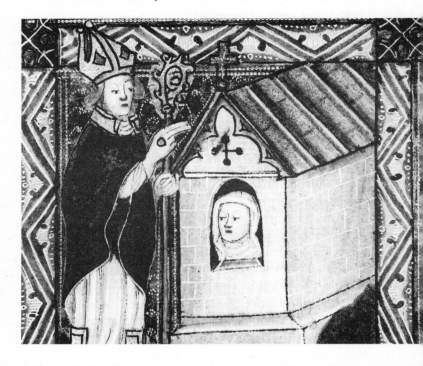

The movement towards a more personal and more internal, a more mystical style of worship was one of the great mental changes of the period. These were the classic symptoms of a world looking for a more direct relationship with God.

JONATHAN SUMPTION

In 1369, Norwich suffered a third wave of the Black Death. A sixth of the surviving population died. It must have felt as though the horror would never end. Four years later, the woman we know only as Julian (named after the church to which she retreated) made a radical decision. At the age of 30, she stepped away from a world of plague and turmoil to become

an Anchoress, vowing to spend the rest of her life as a recluse in a single room, praying to God and meditating on the 'shewings' which He had vouchsafed her.

It sounds like a story from another world. Yet take out the religious language, and it doesn't look so different from the tale of some modern creative genius dropping out of the mainstream to pursue a personal vision. The artist in their garret, and all that.

Then as now, that tale is at best a half-truth. Julian didn't go to dwell alone on some distant island. She became a tourist attraction. Her retreat from worldliness took place within the city walls, in amongst the mighty castle, the cathedral, and the bustling markets of what was then England's second largest city. And it took place in full view: her cell had a large window, at convenient height, through which a fascinated public could and did observe her every act. It was an early version of reality tv.

Like many a modern celebrity, once her reputation as a public spectacle was established, Julian took up her pen to set down her insights and life-wisdom, becoming the first English woman author known to us. Her writings mix long meditations on everyday things like hazelnuts with memorable if vague exhortations to live more fully:

> Our life is all grounded and rooted in love, without love we cannot live.

The public lapped it up. For in response to unprecedented crisis and suffering, a modern sense of the self was emerging – as an individual, seeking his or her own way to truth.

By 1400 Julian was nationally famous. People left money to her church in their wills. Her sayings were copied out (this was, of course, long before printing) far and wide. And then, in 1413, an extraordinary meeting took place between her and another Englishwoman.

EXPLORE FURTHER | *The Cloud of Unknowing* by Anon. (late 14th c.) • 'The Mystic Marriage of St. Catherine' by Sassoferrato, painting (ca. 1650; Wallace Coll.) • 'The Voyage of the Anchorites' by Will McLean, sculpture (1996; Scot. Parliament)

The Book of Margery Kempe
Margery Kempe | 1436–8

Everywhere she went, she would be struck with the sensation, the horror, the sorrow of Christ's passion. She would find it impossible not to fall on the ground and pound the earth. People did not know what to make of her.

LAURA ASHE

The manuscript of the first autobiography written in English was lost for centuries. It was re-discovered only by chance in 1934, when a family was looking for ping-pong balls at the back of a cupboard in an old house. At last, one of us now speaks to us directly. And what a voice it is.

Like Chaucer's characters, Margery loved to go on pilgrimages. But for her, they were serious business. Since her first failed pregnancy, she had been troubled by wild visions and voices (not to mention, repeated business failures). Her travels were a desperate attempt to find sense in it all. She was often accused of heresy by church officials simply because her impassioned weeping and wailing at their shrines went beyond the bounds of what was considered acceptable. At one point she even had a vision of sleeping in the same bed as Christ, and him asking her to kiss him.

Arrested several times, even threatened with burning at the stake, she eventually went – she says that God ordered her – to visit Julian of Norwich. In terms of modern psychology, we might think of it as a troubled, truth-seeking woman going to meet an older female guru who had not only come to terms with her own visions, but had also become famous for them.

> The anchoress [advised] this creature to be obedient to the will of our Lord and fulfil with all her might whatever he put into her soul, as long as it was not contrary to the worship of God and the benefit of her fellow-Christians.

This was the confirmation that Margery sought. Despite those careful reservations, the famous Anchoress seemed to agree that even an uneducated, illiterate woman could be the recipient of personal instructions from God.

The implications were extraordinary, but the time had not yet come for them. To the vast majority of Margery's contemporaries, writing was just marks on parchment: the great truths about God and the world were delivered in images and music. The future might belong to writing, but for the time being creative people working in the older art-forms were still far more important – and, like Margery Kempe herself, they were finding their own voices.

EXPLORE FURTHER | *The Revelations of St. Bridget of Sweden* (14th c.) • *Grace Abounding to the Chief of Sinners* by John Bunyan (1666) • *Margery Kempe* by Robert Glück, novel (1994)

Great East Window

John Thornton | 1405–08 | York Minster

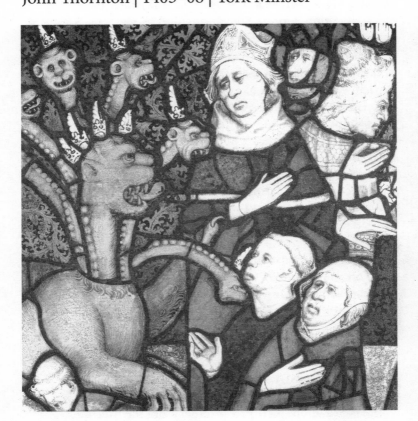

Again, it was the craftsmen who took the lead, working in little individual touches that, once the glass was high up in place, would only ever be seen again by God. By the end of the Middle Ages, our windows had become the envy of Europe.

DAVID ADJAYE

York's magnificent window is witness to a golden age of English art – indeed, the most English age of all. By the early 15th century, even kings spoke the native language

publicly. As artisans criss-crossed the land, refurbishing and extending churches, they confidently adopted and spread a brand-new style which, for the first time since the Conquest, was genuinely, home-grown English. Unlike later Renaissance or Neo-Classical architects, they weren't working to written rules: instead they were led by their own, hands-on understanding of how to spread forces. Their cathedrals and churches developed a look unique to these islands, with cage-like tracery, vertical lines, great towers, spires and soaring vaults. We now call this style the Perpendicular.

Here is daring technical innovation mixed with an almost wilfully undecorated architecture which – when we at last reach the roof – flowers into the most extraordinary fan-vaults. It provided a single, gigantic, Heaven-storming space for communal worship, and the vast new stained glass windows formed fiesta-like backdrops of colour and popular storytelling. Everything about the Perpendicular suggests a desire to flatten out old social hierarchies. These are buildings in the service of God, certainly, but they were also built by and for Everyman: the marvellously individual and expressive faces that peer from John Thornton's new East Window at York Minster were drawn from life, using models found on the city's streets.

The window has been called the Sistine Chapel of stained glass, and like Michelangelo's ceiling, it is the master-work of a thoroughly modern, individual artist who knew what he was worth. By 1405 he was the go-to creator in his field: the York authorities made sure that his contract, for the then-princely sum of £56, obliged him to work personally on the 'histories, images and other things' to be shown.

This rise of the modern, personal artist wasn't confined to stained glass. In music, the most democratic of the arts (you don't need any kind of training or conscious understanding to be blown away by gorgeous sounds) identifiable creators were starting to find new and distinctive voices.

EXPLORE FURTHER | Stained glass windows at St Mary's Church, Fairford (early 15th c.) • John Piper Gallery (River & Rowing Museum, Henley) • The Queen's Window by David Hockney (2018; Westminster Abbey)

Veni Sancte Spiritus

John Dunstable | ca. 1415

You could argue that Dunstable is really the beginning of the Renaissance rather than being a medieval composer, because he had such a profound influence on the generation of continental composers after him. His music should be a source of national pride because he introduced this new style to the continent, and so often the traffic is in the other direction.

RORY MCCLEERY

Veni Sancte Spiritus was first sung at Canterbury Cathedral in 1416 to commemorate the Battle of Agincourt the year before. Up until then, English music was, like the rest of English elite culture, thoroughly dominated by French tastes. But now, a distinct national style evolved out of plainsong chanting: a richer and more complex sound, playing with combinations of high trebles and low basses. It's hard to avoid wondering if this

wasn't inspired directly by the wish to fill the vast, soaring new spaces in perpendicular cathedrals like Canterbury and York.

English music now had its own distinct voice, recognised throughout late-medieval Europe as something unique and special. It's hard now to appreciate how striking and memorable the first audiences would have found this new music – but then, it's hard for us to imagine that Bill Haley and the Comets were once seen as a threat to public order. Luckily, we have documentary evidence of the impact this new English music had. Despite having been fighting us for a century, the French themselves recognised this new soundscape, with its soaring tonalities and interweaving melodies, as something grand: they called it the '*contenance angloise*', and their musicians rushed to copy it.

As with Chaucer and Thornton, people weren't just copying a style. They were copying an *individual with a name and a creative signature*. To us, the idea of creative works being products of one individual genius seems obvious, but in the 15th century, it was something radical. When Dunstable died in 1453, Latin epitaphs were devised in his memory, celebrating how he had 'spread the sweet arts of music throughout the world'. Twenty years later, a French-Flemish composer still named him as the 'chief exponent of the new art which originates with the English'.

Rather like the 'swinging 60s' or 'the summer of love' in modern times, though, the sense of the times being a-changing was limited to a small number of people in the elites of the great cathedral and university cities. Out in the unlit rural landscape, lives still revolved around ancient hopes and fears – and the main place where these stories were listened to and sung was in their parish churches. So much of the decoration of those churches has been destroyed, but in one out-of-the-way Welsh village, a near-miraculous survival gives us some idea of the images that haunted our ancestors' minds.

EXPLORE FURTHER | '*Da gaudiorum premia*' Mass Cycle by John Dunstable (early 15th c.) • '*Ave Regina*' by Walter Frye (15th c.) • 'Music for the Funeral of Queen Mary' by Henry Purcell (1695)

St Cadoc's Wall Paintings

Unknown artists | ca. 1480–90 | St Cadoc's Church

At St Cadoc's, you've got this stencilled pattern in the background, almost like a wallpaper. It's a bit of a trick of the trade: using patterns and simple effects to cover a large space while keeping the focus in one place. We do the same thing.

BRYCE DAVIES, STREET ARTIST

The St Cadoc's wall paintings are some of the most vivid church murals in the British Isles but they were only rediscovered in 2007 during a roof renovation, concealed under 20 layers of limewash slapped on since the Reformation.

Any church more than 500 years old would once have been covered in wall-paintings like this, part of an ancient tradition of

large-scale murals which goes right back to cave-paintings. The Reformation, the radical parliamentarians of the 17th century and Georgian and Victorian re-builders put an end to all that. Yet out on the streets, we have gone back to the future.

In Victorian and Edwardian times, our public spaces were plastered with printed words: announcements, posters, news, advertising. But our modern streetscapes are far more like medieval ones, dominated by visual storytelling: logos, designs, images from film, TV and advertising, pictures from social media. So perhaps it's not surprising that we have once again fallen in love with mural artworks in public spaces. And the techniques remain largely the same.

The paintings of St George and the Dragon, and of the Seven Deadly Sins, are remarkable, but perhaps the most powerful image at St Cadoc's shows a fashionably dressed young man of the late 15th century being led away by a hideous, rotting corpse wearing a shroud which looks rather like a bridal dress.

Worshippers at St Cadoc's were all too familiar with the idea. The Wars of the Roses ravaged England and Wales from 1455 to 1487, and the slaughter overlapped with new outbreaks of the Black Death. No sooner were the wars over, and the Black Death ebbing again, than a new and still mysterious disease known as the sweating sickness killed yet more thousands, including the Prince of Wales himself. No wonder that the idea of being suddenly led away by Death was such a popular motif in art.

But medieval paintings like these were the last of their ilk. For with the new Tudor dynasty (founded 1485), the radical new European learning known as Renaissance Humanism had crossed the Channel. Its signature was the study of Latin and Ancient Greek. So at first, it seemed as though Britain would be bound even more closely to the European mainstream.

Yet in these islands, things are always different. The new Tudor scholars-cum-politicians were about to change our relationship with one another, and with Europe, forever.

EXPLORE FURTHER | 'Trinity', wall painting (11th c.; St. Mary's, Houghton-on-the-Hill) • 'Christ at the Apocalypse', wall painting (early 12th c.; St Mary's, Kempley) • 'Wheel of Fortune', wall painting (12th c.; St Andrew's, Ilketshall)

3. QUEENS, FEUDS AND FAITH

Foxe's Book of Martyrs

The Elizabeth Portraits

The Bacton Altar Cloth

Agnus Dei from Mass for Four Voices

The Penicuik Jewels

The Marian Hangings

On Monsieur's Departure

Beibl William Morgan

The Tragedie of Othello

Our Victorian ancestors believed there was an almost mystical connection between being British, being Protestant, and creating an Empire. They saw the Reformation as the first step in our Imperial destiny.

In fact, it was an accident. Henry VIII was deeply conservative. For most of his life he pursued, at ruinous cost, the medieval dream of being King of France as well as of England. Thwarted, he tried instead to have himself elected Holy Roman Emperor. He was so much part of the established order that in 1521 he published a personal attack on Martin Luther, who had dared to rebel against the Catholic Church. The grateful Pope awarded him the title 'Defender of the Faith', which his descendants still use.

By the late 1520s, his failed wars and double-dealings had left him friendless and bankrupt. Worse, he had produced no male heir. The same Catholic Church which denied him a divorce was sitting on perhaps a quarter of all the land in England. Henry's determination to remarry and refill his coffers gave the chance for a ruthless new elite to tame the ancient power of the Church and take its place as the king's new right-hand men, regardless of the cost.

That cost was huge. But from the rubble of medieval England arose brand new visions. Elizabeth I's courtiers began to talk of a *Brytish Iles* or even, a *Brytish Impire*. The books, poems and plays of her reign, for the first time, speak to us in ways that seem truly ours.

Foxe's Book of Martyrs

John Foxe | 1563

The illustrations are hugely important to the popularity of the *Book of Martyrs*. They're always the most-worn pages. Sometimes people have coloured them in and you even see where the reader has defaced the face of the persecutor.

GEMMA ALLEN

John Foxe's book unforgettably records, in terrifying images of suffering, the greatest cultural trauma in these islands since 1066. In 1534, Henry VIII broke with the Pope, blowing apart the religious unity of Europe and sending us, once again, off on a path all our own. The classically-educated 'new men' who

dominated England's unique institutions – Parliament and the Common Law – seized the chance to supplant the Catholic Church. With a country up for grabs and the executioner's block awaiting the losers, they unleashed a legal war against the Church's wealth, and an ISIS-like culture war on the world of religious art. This created a blank slate for their new story of what 'we' were. People were torn overnight from a place of tradition, where handmade, brightly-coloured images were everywhere, into a brave new world where God's Word, mass-produced in black-and-white print, was the only authority in town.

That was the theory, at least. In fact, Foxe's new tales of nationalised, Protestant martyrdom clearly appealed to a centuries-old tradition of paintings, stained glass, carvings and sculptures showing Christian martyrs. Despite the apparent triumph of the Word, images had lost none of their power, though Protestants were supposedly against all such 'idolatry'. Foxe got away with this by avoiding any representations of God, angels and suchlike, claiming that he was just writing history.

And the *Book of Martyrs* contained a political message that helps explain why it was adopted by the authorities as practically a companion text to the Bible. It was the first printed text ever to claim that England and Scotland were a single state ('in this Realme of England and Scotland'). To us, this idea seems perfectly familiar (whether we approve of it or not), but at the time, the idea of joining two states separated by centuries of warfare, and by a huge swathe of practically lawless territory stretching from Newcastle to Berwick, was radical. Foxe wasn't just declaring religious warfare on the Catholic enemy within, he was loosing the opening salvo of a brand new struggle for dominion over the whole island of Britain.

England and Scotland, ancient foes, were now to be welded into a single state by a common Protestantism, under which both would bow down not to the Virgin Mary, but to the Virgin Queen.

EXPLORE FURTHER | 'The Martyrdom of St Clement' by B. Fungai, painting (ca. 1500; York Art Gall.) • 'Anne Askew' by Hans Eworth, portrait (1560; Tatton Park, Cheshire) • Martyrs' Memorial by George Gilbert Scott (1843; Oxford)

The Elizabeth Portraits

Various artists | 1559–1600

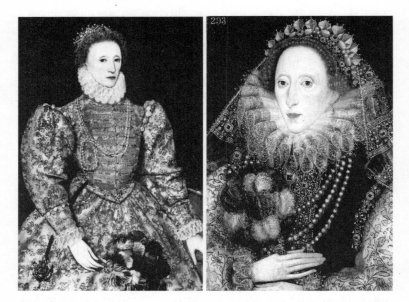

Elizabeth uses portraiture to fashion this image of herself as a sort of timeless political icon. Gloriana the ageless, flawless monarch – eternal. She will never die. That's what the population needs to believe, because there is no heir. She's the Virgin Queen. The portrait creates her as an untouchable figure: *You can't get to me, but you can look at me all the time. Look at me.*

JERRY BROTTON

Elizabeth had narrowly escaped execution under her sister, Mary, and even after she became queen in 1558, her position was insecure. Outside London and the South-East, most of her people were still essentially Catholic in their feelings, and many regarded her as illegitimate. Her position was made still more delicate by the simple fact that she was a woman: England had only ever had one reigning queen before – Mary – and that had

not ended well. To be ruled by an unmarried, childless woman felt like a political impossibility to many.

With the facts intractable, Elizabeth boldly appealed to her subjects' emotions, making the weakness of her position into a virtue. In the Middle Ages the English had been famed throughout Europe for their adoration of the Virgin Mary, and she now mobilised England's artists in the systematic creation of herself as a nationalised replacement: the Virgin Queen.

Her propaganda portraits have survived in our galleries, but in Elizabeth's day they would only ever have been gazed on by the elite. When it came to the ever-fickle English *hoi polloi* (who, as Elizabeth well knew, had loudly welcomed her sister Mary, only to turn against her within two years), clothes were a far more important prop to her regime than pictures because they were seen by far more people. Like a sixteenth-century Evita Peron, Elizabeth gave her people a great show, live: her reign was spent in an incessant round of carefully staged public journeys – 'progresses' – from one palace to the next, constantly changing her look, always on display. And it worked. The common people thronged to see their gorgeously-arrayed sovereign: here, at last, was a glorious female image that you could publicly worship and bow down to without fear of being called a heretic.

> She cheerfully received not only rich gifts from persons of worth, but Nosegays, Flowers, Rose-mary branches, and such like presents, offered unto her by very mean persons… whereby the people, to whom no musicke is so sweete as the affability of their Prince, were so strongly stirred to love and joye.
>
> HOLINSHED

When Elizabeth died, over 2,000 items of clothing, the props of her amazing political theatre, were listed in her inventory, but almost the only survival is a remarkable item from an obscure church on the border of England and Wales.

EXPLORE FURTHER | Miniatures of Queen Eliz. I by N. Hilliard (16th c.; Fitzwilliam Mus., Camb.) • Photos of Queen Victoria & Fam. by Roger Fenton (19th c.; RCT) • Princess Elizabeth at Buckingham Palace by Cecil Beaton, photo. (1945; V&A)

The Bacton Altar Cloth

Unknown artists | 16th c. | Hampton Court

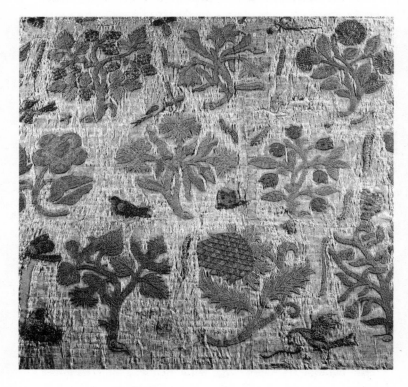

I knew straight away that I was looking at something exceptional. It featured embroidery of a skill and a quality that I'd never seen before. And that embroidery was done on cloth of silver. Now, cloth of silver in the 16th century is reserved for the immediate members of the royal family. And on top of that, it shows evidence of pattern-cutting and bits of seaming that makes it look as though it came from a dress. I had a pretty good hunch that I was looking at something that might have been worn by Elizabeth I herself.

ELERI LYNN

Anyone who has ever held an object crafted in the past, however modest – a cigarette-box made by a great-grandfather, perhaps, or a tapestry sewn by a great-great aunt – knows how such things can send electric arcs of feelings across centuries. But this really was something almost magical: discovered by historian Ruth Richardson in 2015, after it had served for generations as the altar cloth in an obscure country church in Herefordshire, here was a direct, physical line back to the age of Elizabeth and Shakespeare. Small wonder that it caused a sensation in the fashion history world. This is how the discovery was experienced by James Merry, celebrity embroiderer, mask-maker, and frequent collaborator of the Icelandic music icon, Björk:

> I was just blown away. It has this sheen to it, this shining. The whole thing is just glowing and alive. Apart from the fact that it's beautiful, you can see a master at work, almost a virtuoso showing off. It's flawless, there's not one mistake in it. Calling it a piece of 'craft' would be a disservice. It's clearly a masterpiece of art. And it's not art that's stuck in a frame on the wall. It's something you put against your skin, and you inhabit. This was something that Elizabeth actually wore on her breast.

And what you wore on your breast mattered deeply in Elizabethan England. The Queen knew that her subjects were confused and divided by the Reformation, so she offered a kind of religious/political amnesty, proclaiming that she had *no desire to make windows into men's souls*. If people conformed in public, she would not concern herself further; openly refuse to be an Anglican Protestant, and you were in big trouble. Unless, that is, you were an artist Elizabeth happened to like. For she was different. She was the Queen, and her whim was as good as law. Beyond all superficial religious logic, her deep love of one particular art form allowed a notorious heretic to flourish even in her very court.

EXPLORE FURTHER | 'Petticoat Panel' (ca. 1600; V&A) • Queen Eliz. II's wedding dress, designed by Norman Hartnell (1953; RCT) • 'The Elvis Dress' worn by Diana, Princess of Wales, designed by Catherine Walker (1989; V&A)

Agnus Dei from Mass for Four Voices

William Byrd | ca.1592–3

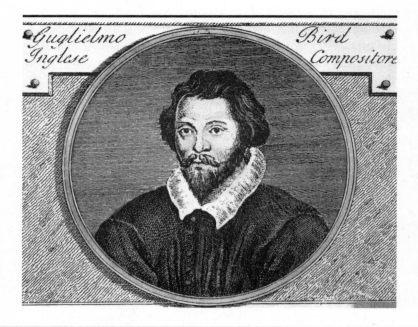

The mass was crucial to Catholics – the cornerstone of their faith and their identity. But Catholic masses were absolutely not allowed in Elizabethan England... In the opening of *'Agnus Dei'* you have each voice enter, then calmly sing these lovely melodies. At this stage it's just typical Renaissance polyphony. Then all of a sudden you're in a dissonant sound world with the voices clashing against each other, with the phrase *'dona nobis pacem'* ('give us peace') repeated again and again by the voices piling up on top of each other.

KATHERINE BUTLER

William Byrd's story shows not just Elizabeth I's artistic taste, but also her political determination. She favoured and protected Byrd even though he was openly a

Catholic, hence theoretically a rebel and traitor. Even as he was composing music for Elizabeth's own court and church ceremonies, paid for by her, he was creating underground music too: private, small-scale Latin masses to be performed in the homes of wealthy *recusants* (those who refused to attend the official Church of England). To us, this music may sound innocuous, but when we recall that singing it could literally have cost the singers their heads, we start to feel the passion.

Byrd's position was akin to that of a non-communist Russian composer under Stalin: such a favourite of the all-powerful ruler that he was allowed to publicly stand apart from state ideology and even, in secret, to write music crying out for an end to the dictatorship and the purges. There were always zealous Protestants keen to denounce him, for he consorted with Catholics who ended up being executed, yet though he was occasionally fined, the Queen more than made up for it by granting him a prosperous estate in Gloucestershire. As she herself said, he was 'a stiff Papist and a good subject'.

A good subject. That was what counted. Radical Protestants were trying to make their brand of Christianity define the whole state. Elizabeth realised the danger to the Throne in that idea (she was right, as James II would find out a century later). By publicly indulging her personal taste in music, she fired a political warning shot. The Reformation was good so long as its anti-Rome drive meant the Queen was all-powerful in her realm – but woe betide anyone who dared suggest that even she, the Sovereign, was bound by Protestant ideology! There was nothing liberal about her support for Byrd; it was all about her own power. And when it came to that, she was nothing if not Henry VIII's daughter. Artistic freedom (if it pleased Her Majesty and sent the right message) was one thing; a political challenge within her own family was a very different matter.

EXPLORE FURTHER | 'The Silver Swan' by Orlando Gibbons, madrigal (ca. 1612) • 'First Light' by Judith Bingham, choral music (2007) •William Byrd Singers, choir (Didsbury, Manchester & touring)

The Penicuik Jewels

Unknown makers | 16th c. | Nat. Mus. of Scotland

Over the centuries, some of the strongest women from some of the biggest dynasties have been empowered by jewels... In the midst of a political-religious war and a battle between two queens, these beautiful objects not only exude craftsmanship, but tell a story.

SHAUN LEANE

These jewels aren't just desirable objects. They are wound up in the story of the personal and political rivalry between two close relatives, each with her own throne on this one island.

In her battle to manage a bitterly divided England, Elizabeth's trump card was the lack of any credible rival around whom opposition might rally. In England, that is. But there was

another powerful state on this island: Scotland, which had been in a permanent state of hot or cold war with England for the past three centuries. The last great battle between the two had only been in 1547. And in Scotland ruled the one person who truly scared Elizabeth: her own cousin, Mary, Queen of Scots.

They had been public rivals right from the start. In 1558, the year Elizabeth became queen, Mary married Francis, son and heir of Henry II of France – who immediately announced that his new daughter-in law was the true Queen of England (as a Catholic, he considered Elizabeth legally a bastard because the marriage of her mother, Anne Boleyn, to Henry VIII had been illegitimate). When Mary returned to Scotland from France in 1561, she brought many jewels with her and continued to add to her collection. These imported treasures would then be handed out, in the ancient way, as personal gifts to supporters, thereby stressing the link between her own court and Catholic Europe. Every Scottish noble who received a French jewel from Mary would be reminded that their Queen had powerful supporters across the water, who intended even greater things for her. And then, in 1566, Mary did the most important thing any Queen could do to secure her power: she produced a male heir, James. The locket in the picture above is thought to depict Mary and her son, the vital new element in the power-game. Small wonder that the childless Elizabeth of England saw her cousin as the most likely person to spark foreign invasion, domestic uprising, or both.

> There's clearly a closeness: they are kin, they are blood. But in the end, they are people who want to kill each other.
>
> JERRY BROTTON

The unspoken jockeying between the two queens turned into deadly political drama when war between Scotland's factions delivered Mary into Elizabeth's hands.

EXPLORE FURTHER | The Darnley Jewel (1571–8; Holyrood Palace, Edinburgh • St. Edward's Crown (1661; Tower of London) • The Spencer Tiara, made by Garrard, later worn by Diana, Princess of Wales (1930s)

The Marian Hangings

Mary Queen of Scots and Ladies-in-Waiting

ca.1569–1584 | Oxburgh Hall

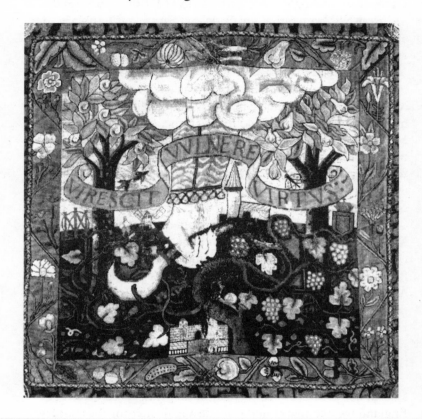

The tapestry shows a barren vine being cut off so that a fruitful line will grow. And it has a motto in Latin: 'Virtue flourishes from wounding'. What does this mean? You could interpret it just as Mary persevering in captivity. But another meaning is possible: that the barren vine of Elizabeth should be cut off and replaced by the fruitful line of Mary.

GEMMA ALLEN

In 1568, Mary had to flee Scotland for exile in England. She was now a veritable serpent in Elizabeth's Eden: a charismatic queen, granddaughter of Henry VIII, with a son, in search of a kingdom. And beyond the River Trent, there were plenty of Englishmen willing to offer her one. The very next year, 1569, the great Northern Rebellion broke out, aiming to put Mary on the throne and restore Catholicism. Elizabeth had to use extreme violence to suppress it, hanging 600 rebels.

For the next 17 years, there was an extraordinary stand-off between the two cousins. Elizabeth was wedded to the idea that royalty (meaning, her own Tudor dynasty) was sacred: after all, her own power depended on that notion. So despite everything, Mary had to be treated as a queen. Yet at the same time she had to be kept utterly powerless. Imprisoned in a gilded cage, Mary was obliged to find a gentlewomanly pastime, and began to embroider tapestries. Before long, however, she began to weave coded messages into her pictures.

This isn't some fanciful idea invented by modern scholars. Mary sent this very embroidery to the Duke of Norfolk (England's premier Catholic peer) and when he was arraigned for treason in 1571, it was presented as evidence in court, helping to secure his execution. People at the time knew exactly what Mary's coded pictures were saying. For us today, they provide a uniquely evocative, close-up sense of a woman who was hopelessly trapped, despite being of the highest blood in the land.

It was because of that blood that Elizabeth hesitated to act against her cousin. Yet there was another way. If the Queen of England were to marry and provide a male heir for the country and the dynasty, none but the most extreme Catholics would ever again consider replacing her with the failed Queen of Scotland. But for Elizabeth, that course itself posed massive problems; now this extraordinary ruler turned creative artist to pen her own literary insight into her dilemma.

EXPLORE FURTHER | Stole, Maniple and Girdle of St. Cuthbert, embroidery (10th c.; Durham Cathedral) • 'Elegy' by Chidiock Tichborne, sonnet (1586) • Martha Edlin's Casket, embroidery (1671; V&A)

On Monsieur's Departure

Queen Elizabeth I | ca.1582

'I grieve and dare not show my discontent,
　　I love and yet am forced to seem to hate,
　　I do, yet dare not say I ever meant,
　　I seem stark mute but inwardly do prate.
　　I am and not, I freeze and yet am burned,
　　Since from myself another self I turned'

Women are supposed to be ideal, silent, preferably absent. But here is Elizabeth writing and speaking, essentially laying open her own mental turmoil for all to see.

NANDINI DAS

'For all to see.' There's the rub. It's tempting to see this poem as an authentic revelation of the real 16th-century woman behind the image of the Virgin Queen. She who ruthlessly crushed the great Northern Rebellion now seems as racked by existential doubt as Shakespeare's Hamlet (compare 'I am and not…' with 'To be, or not to be…') She twice claims that she 'dare not' follow her wishes. Dare not? Who could possibly forbid the Queen of England to do as she wants?

The only answer is: the Queen of England herself, who dramatises an internal civil war between Elizabeth the private woman with human desires ('soft and made of melting

snow') and Elizabeth the Queen with her duty to her realm. Duty wins out. The Queen, her own tragic heroine, must live without love.

But is it really an authentic revelation of Elizabeth's feelings? It certainly seems that she was genuinely attracted to the Duke of Anjou (who she called '*Monsieur*' in her many letters to him.) In 1581, she told her closest advisers, Leicester and Walsingham, that she intended to marry him. The plan, though, was fraught with danger. The laws and customs of the age meant that her husband would in practice take over from her. Anjou was the son of the King of France, and if Elizabeth married him, her people might turn against her, just as they had turned against her sister Mary when she married the King of Spain. The long-proposed wedding was finally called off in 1583.

It was the last throw of the marital dice. In the end, Elizabeth had chosen personal power over marriage. Yet that choice itself imperilled her position. She was now 50 and no amount of flattery could hide the fact that she was never going to produce an heir. How could she stop her courtiers and grandees looking over their shoulders for the next dynasty? How could she stay in real power? The Tudor propaganda machine, forged in the battle of the Reformation, had the answer. It's from this time on that it begins to systematically present Elizabeth as the almost superhuman Virgin Queen. Her poem was part of this campaign, presenting her not as a ruthless queen determined to preserve her own power, but as a conflicted woman who has finally chosen, with deep sadness but out of a profound sense of duty, to be wedded only to the nation itself.

It was a brilliant vision. But it wasn't Elizabeth's sole survival tactic. What if the nation she was wedded to wasn't England alone? This idea was to change everything for all of us, and it threw a vital lifeline to an ancient culture.

EXPLORE FURTHER | *The Faerie Queene* by Edmund Spenser (1590) • Queen Victoria by Franz Winterhalter, painting (1843; Royal Collection Trust) • *The Fifth Queen* trilogy by Ford Madox Ford, novels (1906–1908)

Beibl William Morgan

William Morgan | 1588

❧LLyfr cyntaf Moſes yr
hwn a elwir GENESIS.

PENNOD I.
Creadwriaeth y nêf, a'r ddaiar, 2 Y goleuni a'r ty-
wyllwch, 8 Y ffurfafen, 16 Y pyſc,yr adar, a'r ani-
feiliaid, 26 A dyn. 29 LLynniaeth dyn ac anifail.

YN y dechreuad y * cre-
awdd Duw y nefoedd
a'r ddaiar,
2 A'r ddaiar oedd af-
luniaidd, a gwâg, a
thywyllwch [ydoedd]
ar wyneb y dyfnder,ac
yſpryd Duw yn ym-
ymmud ar wyneb y dyfroedd.

wyth eu rhywogaeth : a Duw a welodd mai da
oedd.
13 Felly y'r hwyr a'r borau a fu, y tryd-
ydd dydd.
14 Duw hefyd a ddywedodd, * bydded
goleuadau yn ffurfafen y nefoedd i wahanu
rhwng y dydd a'r nôs : a byddant yn arwydd-
ion, ac yn dymmorau, ac yn ddyddiau, a bly-
nyddoedd.
15 A byddant yn oleuadau yn ffurfafen y
nefoedd, i oleuo ar y ddaiar : ac felly y bu.
16 Oblegit Duw a wnaeth y ddau ole-
uad mawrion, y goleuad mwyaf i lywodraethu

If the Bible had not been translated, I don't know whether the Welsh language would have survived or whether the Welsh nation would have developed into the Nonconformist nation, which led on into the Labour nation and the radicalism of the 20th century. I don't know whether the Welsh language as a literary language would be alive today.

MARION LOEFFLER

In 1536, under Henry VIII, Wales was united with England. After a millennium of resistance, violent until 1415, it seemed the end for a distinct Welsh identity.

Henry's ministers initiated a carrot-and-stick programme. The carrot, for the gentry of Wales, was being allowed to become MPs and get their snouts into the pork-barrel of Parliament, where the riches plundered from the monasteries were being divvied out; the stick was that English was to be used in all public and legal business.

Similar policies were being tried in Ireland. But they weren't working. The Irish refused to become English Protestants, and Ireland was fast becoming a graveyard for Tudor armies. Loyal Welshmen began warn that Wales, still a stronghold of Catholicism, might turn into a haven for rebels. So Elizabeth changed tack, profoundly, in a way which echoes to this day. Foxe in 1563 had hinted at joining England to Scotland, and in 1557 a brand-new term was coined: the *Brytish Iles*.

The radical new plan, different from anything ever proposed on these islands, was for a political unit which nonetheless officially recognised cultural differences. And so, in 1588, the ancient language of Wales was accorded the ultimate honour: a Bible translation in a royally-sanctioned printing. It was a huge undertaking and changed the whole status of the language. The new Welsh Bibles were almost all printed in London, and that meant bringing to the capital people who understood what was being typeset. For the first time, Welsh people of standing were formally employed by the government, in London, in affairs of the Welsh language. Having the Bible in your own language (whichever language that might be) was also an invitation to become literate, so that you could pore over God's Word in your own home. As with the King James Bible in English, Morgan's cadences became the sinews of a new, national literary language which had no limits.

Elizabeth also commissioned a Bible in Gaelic, with the New Testament ready for print in 1598, just as she was preparing a last great attempt at truly conquering Ireland. She had openly given up trying to make everybody in these islands English. Instead, she planned that her multilingual *Brytish Iles* would be united by loyalty, and by service to the state. This last quality was the great merit claimed, at the moment of his death, by an extraordinary new tragic hero being created in Elizabeth's last days.

EXPLORE FURTHER | *Book of Taliesin*, poems (6th?–14th c.; Nat. Lib. Wales) • 'The Family of Henry VIII: an Allegory of the Tudor Succession' by Lucas de Heere, painting (ca. 1572; Nat. Mus. Wales) • King James Bible (1611)

The Tragedie of Othello
William Shakespeare | 1604

Othello is eloquent and brave on the same level as any of the
great tragic heroes.

NANDINI DAS

The first black character in English literature isn't a villain, or
a servant, or comic relief, but a mighty general charged with
defending Christendom itself. Shakespeare's audience had no
trouble with that. For if his London was not our London, neither
was it the London of the Empire and the Slave Trade. If you said
that somebody was 'black', people might assume you were talking
about the colour of their hair. That doesn't mean Londoners

were happily multicultural folk. They weren't. 'Blackamoors' were easily identified as rivals for jobs and state handouts when times got tough. At such times, though, Tudor Londoners were notoriously hostile to anybody who threatened their meal tickets: the Flemish were regular targets, and the great base of the German Hanseatic traders, the London Steelyard, was shut down in 1598 after popular agitation. Londoners could be deeply xenophobic, but they weren't racists. Nobody had yet invented the idea that skin colour decides your status. There were few Africans in Shakespeare's London, but those few were people of wealth and importance, or their servants. Othello was, in fact, a very fashionable choice of hero: Elizabeth was seeking Muslim alliances against Catholic Europe, and Shakespeare seems to have begun the play shortly after the first ever visit of a Moroccan ambassador to London.

Yet Othello's skin colour is constantly noted, and seems an invitation to make slurs and insults. Those insults show that one of the staples of modern racism – black males being seen as a sexual threat to white society – was already familiar. But Shakespeare isn't talking as himself, or even as his society. This is drama, with characters, and the vast majority of those insults come from Iago. They are about *him*, born of his murderous bitterness and sexual resentment. Talk like that, says the play, and you are like Iago, pouring poison in people's ears for your own ends.

And the fact is, Iago fails. Othello is caught red-handed, having just murdered his wife, yet he demands – and is accorded – the ultimate aristocratic privilege of being allowed to enact his own death by suicide. In the England of Elizabeth I, what really matters is not the colour of Othello's skin. It's that he has 'done the state some service'.

But by the time *Othello* was performed in 1604, that state – which Elizabeth alone had held together – was entering its greatest crisis.

EXPLORE FURTHER | 'The Moor of Venice' by Giovanni Cinthio, prose (1565) • Portrait of Ayuba Suleiman Diallo by William Hoare, painting (1733; National Portrait Gallery • 'All Night Long' dir. Basil Dearden, film (1962)

4. TO KILL A KING

The Tulip Stairs

Philip Herbert, 4th Earl of Pembroke, and his Family

The Teares of Ireland

Cromwell Portraits

Paradise Lost

Micrographia

The Carved Room, Petworth House

The Rover

Dome of St Paul's Cathedral

In 1603, Elizabeth I died. The new king, James VI of Scotland, now also James I of England, wanted to unite his two realms, which had been at open or undeclared war for centuries, into one single, brand-new country.

> Wee have thought good to discontinue the divided names of England and Scotland... and doe intend and resolve to take and assume... the Name and Stile of KING OF GREAT BRITTAINE.
>
> JAMES I, PROCLAMATION OF 20 OCT 1604

If James got this 'Great Brittaine', it might be beyond the control of London's Parliament. So MPs rejected it. Furious, the king threatened to rule alone, and began to colonise Ireland with families from Southern Scotland and Northumberland. Ulster was the testing-ground for his new 'Brittish' identity, centred on loyalty to the Crown.

A fresh tension was born within these islands, which remains unresolved up to our own day. Would the south-east of England, represented by Parliament in London, dominate the entire archipelago? Or were southern Englishmen going to be just one culture within a greater, multinational, royal state? This question culminated in the Civil War, when we killed more of us, proportionally, than the Germans did in World War I, and Cromwellian 'Englishness' was briefly triumphant.

But before the shooting war came decades of cultural war. The arts were the great weapon in this struggle. In 1616, Inigo Jones fired the opening shot.

The Tulip Stairs

Inigo Jones | 1635 | Queen's House, Greenwich

Staircases have always captured our imagination because they take us to different places, both spiritually and literally – almost like the ascent to paradise. The Tulip Stairs pushed technical boundaries to a point that, frankly, we've not gone beyond. You can't have that kind of complete equilibrium between elegance and innovation, between power and comfort, without it being art.

AMANDA LEVETE

I n 1616 the architect and designer Inigo Jones (1573–1652), son of a humble Welsh-speaking cloth worker, began construction of the Queen's House at Greenwich, transplanting the secrets of Palladian architecture from Renaissance Italy to London. Radical in every way, its stand-out feature is the Tulip Staircase. Nobody here had ever seen anything like it. Until

now, even the grandest staircases in the land had been gigantic versions of normal constructions. People might have known spiral staircases from medieval abbeys, cathedrals and castles, but these all wound around a mighty stone column. The Tulip Stairs were entirely self-supporting – and how can anything support itself? At first sight, it seems impossible. Even today, merely gazing up at it is enough to give you vertigo.

But however stunningly beautiful it is, and however important in the story of British architecture, the Tulip Staircase wasn't just an aesthetic masterpiece. It was also politics, expressed in stone. The 16th-century Reformation had unleashed the word, and with it early dreams of democracy. Against it arose the Counter-Reformation. By the start of the 17th century this had created a new artistic style in Europe, which we know as the Baroque. It marshalled all other forms of creativity – painting, sculpture, theatre, architecture, music – to refute the Reformation. The core message was that kings reigned by heavenly decree, so to resist them was essentially the same as resisting God Himself. Inigo Jones's staircase brought this culture war into England.

Imagine watching a king come down a traditional, oaken switchback staircase. Subtly, you understand that this is just another human, living according to the same laws of gravity as you. However grand he is, his power is of this world. Now imagine watching a royal personage descend Jones's seemingly endless cantilever, apparently supported by nothingness, as if denying gravity itself. It must have seemed like a demigod magically descending from a higher realm beyond human questioning, located somewhere in the blue heavens above towards which the eye was inescapably led. Who would dare question a being who could command stone to stand, impossibly, like this?

Or a magnificent being, larger than life and awesomely realistic, as painted by Anthony van Dyck?

EXPLORE FURTHER | Plas Teg staircase, des. by Robert Smythson? (ca. 1610; Plas Teg, Flintshire) • Dean's Staircase, des. by Christopher Wren (1705; St Paul's Cathedral) • Helical staircase, des. by Foster + Partners (2002; London City Hall)

Philip Herbert, 4th Earl of Pembroke, and his Family

Anthony van Dyck | 1635 | Wilton House

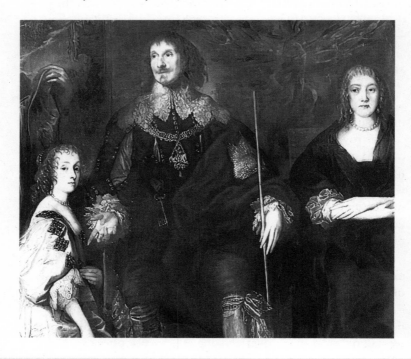

You can see why Van Dyck blew people's minds. Before he came on the scene, there was still a Tudor way of painting portraits. Every pearl and every stitch was there – but it didn't look real. What Van Dyck was able to do was *make you look real*. That is pure magic. He found a new level of reality that blew everybody else out of the water.

TAI SHAN SCHIERENBERG

Anthony van Dyck (1599–1641) made his name as a purveyor of sheer, real-looking magnificence to his sitters, outdoing even his master Rubens. That magnificence was part

of the Baroque cultural war to persuade European peoples that the social order was backed by God. During his visit to Madrid in 1623, the future Charles I of England saw the effect with his own eyes. The struggle between James I and Parliament had by now almost paralysed the country and after he inherited the throne in 1628, Charles set out to fill his realm with Baroque art. Van Dyck followed the money to London where, in 1632, he was officially installed as portrait painter to the king, knighted, and given the use of a splendid London house as well as a fine country retreat. His portraits of Charles became the artistic wing of the king's campaign to rule as a true, absolute monarch, independent of Parliament.

This royal patronage meant that the nobility of England queued up to get some van Dyck of their own. Among the first was the Earl of Pembroke, one of the king's closest allies, who in 1635 commissioned the largest painting van Dyck ever made. On the surface, it appears to celebrate one of the grandest families in the country in their pomp. It suggests that the nobility, as well as the king, are there by God-given right.

But there's a strange tension in the picture. The Earl's wife is almost blatantly detached from things and there's no real sense of human contact within the other family members. Somehow – this is the fascination of art – van Dyck, while apparently delivering glorification, seems to have sensed that here was a world on the edge of a deluge.

For to Puritan Englishmen, this kind of gorgeous, European, class-conscious, show-off art was prideful and wasteful. Claiming that they based both their artistic tastes and their politics solely on the Word of God, they saw supporters of art like this as idolaters and likely closet Catholics – hence traitors to the true Protestant England.

The cultural war between the visual glories of the European Baroque and the plain black-and-white of the Puritans' printed Bibles was about to blow hot.

EXPLORE FURTHER | 'Charles I in Three Positions' by A. van Dyck (1635–6; Windsor Castle) • Double Cube Room, des. Inigo Jones & John Webb (ca. 1653; Wilton Hse.) • 'The Graham Children' by W. Hogarth, painting (1742; Nat. Gall.)

The Teares of Irelande

Wenceslaus Hollar | 1642 | Trinity College, Dublin

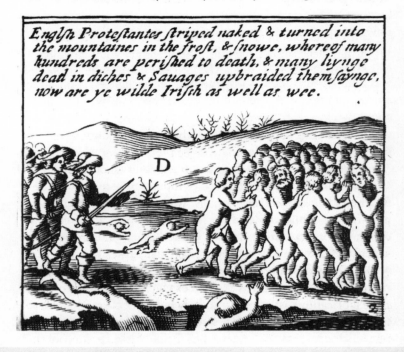

English Protestantes striped naked & turned into the mountaines in the frost, & snowe, whereof many hundreds are perished to death, & many lyinge dead in diches & Sauages upbraided them sayinge, now are ye wilde Irish as well as wee.

Disgruntled native Irish Catholic land-owners in the northern province of Ulster launched a pre-emptive strike on 22 October, hoping to force concessions from the king, as the Scottish covenanters had already done. The Catholics seized key strongholds in Ulster, and drove Protestant settlers from their farms and homes. Thousands of terrified refugees fled to Dublin, Scotland or England, bringing with them stories of atrocities by the Catholic insurgents.

MICHEÁL Ó. SIOCHRÚ

The news from Ireland appeared in London just as the muskets were being loaded for England's own shooting war. And it appeared at the very moment when printing, which had

always been subjected to strict censorship, was suddenly liberated by the collapse of Charles I's regime. A Protestant clergyman, James Cranford, quickly produced what he claimed was:

> a true Relation of the bloudy Massacre and damnable Treason of the cruell Papists… tending to the utter ruine and extirpation of all the Protestants there: With a list of the severall tortures, cruelties, outrages, on the bodies of poore Christians… illustrated by Pictures.

Just as in internet politics today, the real impact wasn't in the words but the visuals. To produce them, Cranford hired Wenceslaus Hollar, a Czech-German engraver who'd come to England in 1635. Though his own sympathies were royalist (he fought for the king in 1645), Hollar was a very modern artistic gun for hire, willing to work for anyone who paid. He certainly delivered for Cranford in 1642. Even today, the physical and sexual violence here is enough to make the viewer wince.

But if you look more deeply into these hideous images – which modern historians dismiss as gross exaggeration or even complete fabrication – something quickly becomes clear. This story isn't really about Ireland at all. Look closely at how the murderous rebels are shown. They may be labelled 'wilde Irishe', but the pictures say something very different. These aren't portrayals of 17th-century rural Irish tribesman. They are pictures of English Cavaliers, expensively dressed in the latest English Court fashion, exactly as in van Dyck's pictures (see previous page). Exactly, indeed, as King Charles himself dressed for van Dyck.

This early fake news is little to do with Ireland in 1641: it's all about taking sides in the England of 1642. The real message is that the brutal murderers are the King and his Cavaliers, here in London. And it worked, for over the next three horrific years, the capital was the vital fortress which won the war for England's first and only military dictator.

EXPLORE FURTHER | 'The World is Ruled & Governed by Opinion' by Wenceslaus Hollar (1642; BM) • 'The Fenian Guy Fawkes', cartoon by John Tenniel (1867; *Punch*) • 'Kaiser's Corpse Factory', cartoon by Leonard Raven Hill (1917; *Punch*)

Cromwell Portraits

Samuel Cooper | ca. 1650–51 | Bowhill House

The wart! This is where the 'warts-and-all' concept comes from.
Cromwell would have certainly had the power to tell a portrait
painter not to put the wart in.

PLATON

The career of Samuel Cooper (1609–1672) is the perfect
illustration of just how powerful art and artists were during
England's bloodiest years. Cooper made his name and liveli-
hood in the 1630s as the great purveyor of portable miniature
portraits to the aristocracy. You might imagine that this mar-
ket would have dried up in the radical Puritan republic, but
not a bit of it: Cooper's exclusive 17th-century selfies were so
sought-after that he was able to navigate the Civil War without
breaking step. Both sides knew that imagery was vital, and he
delivered it like nobody else.

So in 1649, the now all-powerful Oliver Cromwell sat for Cooper. That first session resulted in the usual aristocratic miniature. But there was something very unusual about it. Up until now, virtually every one of Cooper's miniatures had shown the sitter staring directly at the viewer, as had almost every English portrait of a monarch since Richard II (c.f. the 'Westminster Portrait' in chapter 2). In a very few portraits of Elizabeth I and Henry VIII, the gaze is not quite directly at the viewer, but this happens only when the face is at such an angle that a direct gaze would leave the eyes exaggeratedly in the corners of the eyelids, or else when the sitter's eyes are trained on something like the scene of a great triumph on the battlefield. The subliminal idea was that you were looking at someone whose power and status rest on a great action, rather than someone who was simply born to his status. Cromwell had himself portrayed with his gaze fixed firmly elsewhere, yet with no such glorifying backdrop.

And he clearly thought he'd got it right. A year later Cromwell came to Cooper again, but for the conventional, life-size portrait shown above. This time he famously insisted that he be painted 'wart-and-all' – and again chose to present himself looking away and past the viewer, at some private vision. It's one of the most famous and enigmatic paintings of any British ruler.

When, after Cromwell's death, Charles II was restored to the throne, he almost immediately hurried to Cooper's studio, to have himself painted in exactly the same new pose. Perhaps the secret hint was that this king, who had returned only by agreement with Parliament was not only the rightful heir of his father, but also, in some way, of Cromwell himself. One way or another, though, Royalty was back – which meant trouble for one great writer.

EXPLORE FURTHER | Various portraits of Cromwell (Cromwell Museum, Huntingdon) • Catherine, Duchess of Cambridge by Paul Emsley, painting (2012; NPG) • 'Ugly – Portrait of Robert Hoge' by Nick Stathopoulos (2014; NPG)

Paradise Lost

John Milton | 1667

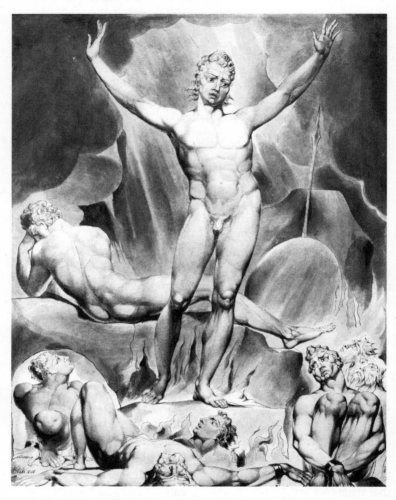

The reason Milton wrote in fetters when he wrote of Angels &
God, and at liberty when he wrote of Devils & Hell, is because
he was a true Poet and of the Devil's party without knowing it.

WILLIAM BLAKE

Paradise Lost, by John Milton (1608–1674) is a matchless witness to an artist in doubt and confusion. Milton had actively supported the English Republic and the execution of Charles I, so when the Puritan attempt to impose Heaven on Earth in England by the sword fell apart at Cromwell's death, and Charles II returned, the poet was right in the firing line. Arrested and confined in the Tower, he only survived thanks to the intervention of powerful friends. How was a great writer to react to the destruction of his dream? The opening of his poem rings with a longing for explanation.

> What in me is dark
> Illumin, what is low raise and support;
> That to the highth of this great Argument
> I may assert Eternal Providence,
> And justifie the wayes of God to men.

But what a strange creation this is! Milton's conscious politics were all about Puritan modesty and democracy. Yet if ever a writer set himself up as a heroic figure chasing immortality, it is he. How can God need 'justifying' to His own creatures? Surely the whole point of the Reformation was that the Bible is the word of God itself, open to all men in their own language, in need of no complex interpretations? And why does Milton invoke the 'Muse', a figure unknown to the Bible but ubiquitous in the writings of classical Greece and Rome? How dare he say that this Muse 'from the first Wast present, and… satst brooding on the vast Abyss' – that is, making this pagan figure from the ancient world sound identical to the Christian God of the Bible? Above all, how did such a religious man come to use, as the chief actor of his great poem, none other than Satan? Here, like nowhere else, we see that whatever artists intend, great creations obey no laws but their own. And that was fitting, because the greatest revelations of Charles II's reign were the laws we all obey: those of Nature itself.

EXPLORE FURTHER | *Areopagitica* by John Milton, pamphlet (1644; British Lib. • 'Satan Arousing the Rebel Angels' by William Blake, watercolour (1808; V&A) • *His Dark Materials* trilogy by Philip Pullman (1995–2000)

Micrographia

Robert Hooke | 1665

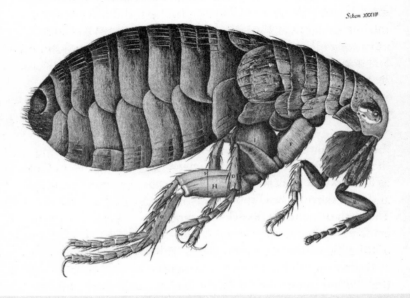

Before I went to bed I sat up till two o'clock in my chamber reading of Mr. Hooke's microscopic observations, the most ingenious book that ever I read in my life.

SAMUEL PEPYS

In Europe, the power of the Catholic Church obstructed the science of men like Galileo. But England had experienced its own religious dictatorship under Puritans for whom the Bible was the only knowledge that mattered. With the Restoration, England won a unique intellectual freedom, backed by the king himself, centred on the newly-formed Royal Society. Robert Hooke (1635–1703), its Curator of Experiments, turned Galileo's technology in on itself and in 1665 his *Micrographia* revealed an astonishing new world hiding in plain sight.

As Hooke put it, the trick was 'to draw with a sincere hand and a faithful eye'. This didn't mean that Hooke and his

colleagues were anti-religious. On the contrary, the idea was that by a scientific, neutral observation of the world, free from erroneous human ideology, we would best understand the miracle of God's creation. English thinkers, shunning both the intellectual straitjacket of the Catholic Church and the wild salvationism of the Puritans, were now insisting that we should go back to basics.

The first plate in Hooke's micrograph is a sort of splodged circle, a wavy line and a funny sort of blunt dagger. These are a full stop, the edge of a razor and the point of a needle. Hooke's magnification reveals to us their man-made imperfections. In the rest of the book, though, he draws objects from nature and they are perfect – because they've been made by God. For Hooke as for Newton, you can't separate the desire to get nearer to God and the desire to know about the world that God has created. The birth of 'natural philosophy' – understood as the search for evidence of God in the natural world – was the birth of that way of thinking which became known as 'English empiricism'.

Distrusting all high-flown, abstract theory, insisting that truth is to be found only in the observable world, this philosophy was vital in preparing the intellectual ground for the Industrial Revolution, and it has influenced the way we write, build, carve, paint, film and compose ever since. It may also be why Britain has produced so few great abstract painters, experimental composers, self-consciously modernist writers, rule-breaking cinematic *auteurs* or gorgeously impractical architects.

This very British insistence that what really matters is real things, not ideas, was born in the minds of people like Robert Hooke, who had personally experienced a country almost destroyed by extremist dreams. They proclaimed that the world doesn't run on invented human laws, but on the laws of nature. Transmuted into artistic practice by a craftsman of genius, such ideas flowered in some of the greatest wood-carvings of all time.

EXPLORE FURTHER | 'The Flea' by John Donne, poem (1590) • Copy of Hooke's microscope (Science Museum, London) • '2020: The Sphere that Changed the World' by Angela Palmer, sculpture (2020; Science Museum, London)

The Carved Room

Grinling Gibbons | ca. 1692 | Petworth House

Legendary artist, sculptor, craftsman – and the greatest of decorative carvers in British history, Grinling Gibbons left an indelible mark on the cultural identity of the nation. He had an unequalled ability to transform solid, unyielding wood and stone into something truly ethereal. His masterpieces adorn palaces, country houses, churches and museums around Britain.

GRINLING-GIBBONS.ORG

If Hooke's drawings and Milton's writings were all about justifying 'the ways of God to man', then Grinling Gibbons (1648–1721) turned the principle into 3-D. In stone, and above all in wood, this hands-on, self-taught artist from an obscure Anglo-Dutch background produced replicas of nature so exact that some of his carved flowers moved with the natural breezes,

as if God's original and man's replica had become one and the same.

Nothing could be a more perfect example of English empiricism in creative action: Gibbons's carvings seem so alive precisely because they are not strictly symmetrical, seemingly not planned according to any human system, apparently just recreating the patterns of the natural world. The difference can be shown better than told, by comparing one of the famous carvings from Petworth to a detail from a Louis XIV headboard of the same period from France.

In the French carving, symmetry is clearly the dominant ethos. In Gibbons, though the effect is broadly symmetrical, the details are very much not. This is characteristic of the contrast between French and English art in this period, and is not limited to carving. French drama was supposed to conform strictly to the so-called 'unities' laid down by Louis XIV's scholars. English drama obeyed no visible rules, which is why Voltaire accused Shakespeare of being great but 'barbarous'. He would have been even more shocked if he'd seen the massive stage hit by our first great female dramatist.

EXPLORE FURTHER | 'The Stoning of St. Stephen' by G. Gibbons, wood-carving (ca. 1680; V&A) • 'Trophy of Spring' by T. W. Wallis, wood-carving (1851; Louth Museum) • Fretwork Chair by A. Mackmurdo (1882; William Morris Gall.)

The Rover

Aphra Behn | ca. 1677

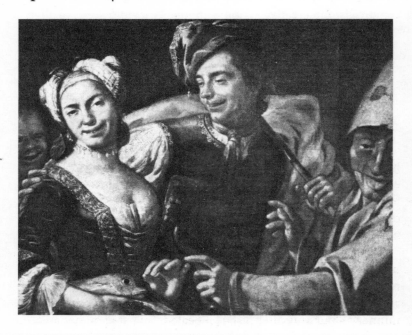

Aphra Behn was one of the most successful dramatists of the Restoration, after that extraordinary transformation from the closed theatres of the Commonwealth to the re-opened theatres of Charles II's reign. It's a world where women are on stage – and it's bawdy.

HANNAH DAWSON

With Aphra Behn, women arrive on the English stage for the first time. Charles II, who loved theatre and actresses, commanded this by Royal decree. For the first time, a woman was able to write plays with women as the lead characters. At first sight, Behn's greatest hit, *The Rover*, set in Naples during its notorious Carnival, seems to be a pure festival of liberation. Our Heroine, Hellena, is meant to be headed for a nunnery – but she

has no intention of going. At least, not yet. Anyone who's ever been to the theatre can imagine what a good actress would make of this speech from the opening scene:

> Prithee tell me, what dost thou see about me that is unfit for Love – have not I a world of Youth? a Humor gay? a Beauty passable? a Vigour desirable? well shap'd? clean limb'd? sweet breath'd? and Sense enough to know how all these ought to be employ'd to the best Advantage: yes, I do and will.

This looks like a thoroughly modern world, a 17th-century version of 'Sex and the City'. Hellena's determination to enjoy herself leads her into a full-blown comic world where sex is everywhere. Behn uses the full repertory of comedy: mistaken identities, masks, overhearings, cross-dressing, lies and deceptions. There's nothing like Victorian morality on show here. And in the end, love triumphs despite everything.

Yet this is a world with darker and more dangerous undertones than we would find in modern comedies of sexual manners. Hellena is permitted to have very earthly desires, and ultimately marries her beloved rather than going into the nunnery – but only after he has repeatedly cheated on her and even (twice) tried to rape her sister. It's comedy dancing on the edge of tragedy. Behn is giving us a very double-edged picture of Restoration liberties. Women are now free – but free to enter, at their peril, a world in which even the hero can barely distinguish between a free woman and a prostitute, or legitimate desire and rape. In this world, almost irresistible drives are only just controlled by civilisation. And as with Behn's portrayal of sex, so with England's politics: the culture war that had resulted in regicide and military dictatorship just wouldn't go away.

In fact, even London's great new cathedral, rising from the ashes of the Great Fire, was deeply implicated in what seemed on the verge of becoming a second Civil War.

EXPLORE FURTHER | 'Against Constancy' by John Rochester, poem (1670s) • *Oroonoko: or, the Royal Slave* by Aphra Behn, prose (1688) • *A Room of One's Own* by Virginia Woolf (1929)

Dome of St Paul's Cathedral
Christopher Wren | ca. 1675–1710

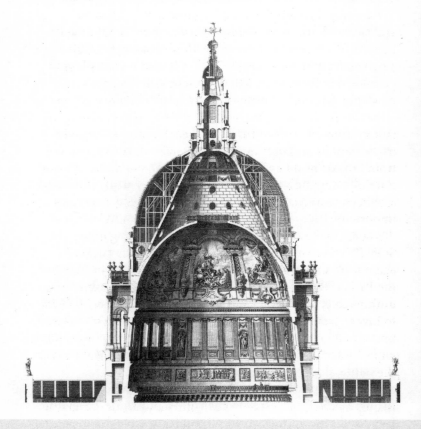

It has been ripped out of Rome and dropped into a scorched city where three quarters of the population were homeless. It's possibly the most important British building, but it couldn't be more European.

THOMAS HEATHERWICK

This contradiction lies at the heart of Sir Christopher Wren's masterpiece. It was a mighty statement of the self-confidence of England, and its architecture a direct challenge

to Rome. Yet it was also a piece of Europe – more particularly, a piece of Louis XIV's France – transplanted into the heart of England.

Part-way through the work, Wren was given detailed architectural drawings of the greatest new royal building in Louis XIV's France, *Les Invalides*. These drawings had been a personal gift from Louis to Charles II, and it seems highly possible that they came with explicit instructions from the new king, James II – who admired Louis's absolutist regime – that Wren should revise his design. The weight of the great lantern (directly copied from the French example) resulted in the famous architectural cheat whereby the dome you see from outside bears no relation to the structure of the interior. London's mightiest building is both a master-work of British architecture and a completely derivative, wholly inauthentic, imported trick.

Which makes it the perfect reflection of the age. Even as St Paul's was rising to this new design, events in England again took a unique turn. With civil war looming in 1689, the Parliamentary faction of the English elite did something unthinkable: they invited William, the Dutch Prince of Orange, to invade from Holland. James II fled and London was placed under Dutch military government for 18 months, until William nailed down his new throne by defeating James's last forces at the Battle of the Boyne in Ireland in 1690.

By the time St Paul's was consecrated in 1697, things in these islands had been decided after a century and a half of cultural and physical war. The King of England and his Parliament were on the verge, at last, of full control over the British Isles, and Protestantism was triumphant. But look more closely: this was no victory for 'English culture'. The new king was a European prince who barely spoke English, Baroque art was now the only game in town, and something quite extraordinary was in the wings. England itself was about to be abolished as a separate state.

EXPLORE FURTHER | The Monument, des. by C. Wren & R. Hooke (1671–77) • Castle Howard Mausoleum, des. by N. Hawksmoor (1726–9) • Liverpool Cathedral, des. by Giles Gilbert Scott (1904–1978)

5. CONSUMERS AND CONCIENCE

Estate agents across these islands yearn for *Georgian* property to sell. Somehow, that word has come to stand for something quintessentially traditional, picture-postcard *us*, whether it's in the Lanarkshire countryside, a Dublin square or a London street-scape.

Yet the Georgians were perhaps the most radical of all the generations in our history. England's elite had stared into the abyss during the Civil War and Cromwell's ISIS-like populist dictatorship. When open warfare loomed again under James II, they made a series of extraordinary moves which changed all our lives forever.

In 1688–90 they invited a Dutch prince, William of Orange, to invade England, then Ireland. Next, they abolished those old enemies, England and Scotland, as separate realms, creating a new state called *Great Britain* in 1707. Finally, as if confirming that this new realm was a clean break with the past, they chose as its first king an obscure German prince who could barely speak English.

Everybody who was anybody in Georgian Great Britain and Ireland had to be classically educated, speaking and reading Latin, Ancient Greek and French. The culture of this ruling class was completely artificial, but that was its whole point: since it belonged to no particular nation, it could be learned and adopted by anybody with enough money. This made it the perfect way to incorporate the upper castes of Scotland, Wales and Ireland. For the first time, the whole British Isles had a unified elite. Under them, it set out to conquer, and even enslave, the world.

Harewood House

Robert Adam & John Carr | 1771

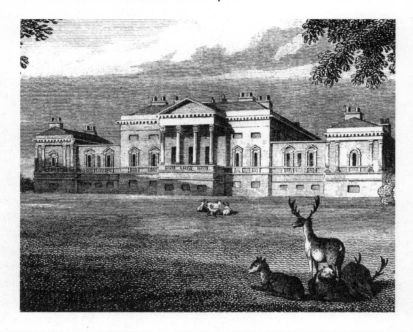

I grew up in a small council house in London, and we would get taken on day trips to the national heritage sites. It was amazing. The scale and ambition – and that sense of entitlement, or whatever you want to call it. The idea of 'you have arrived!'

THOMAS J. PRICE, ARTIST

Begun in 1759, Harewood House parks a great chunk of supposedly Greco-Roman culture in Yorkshire. In the Palladian style which has come, by some alchemy, to be considered typically British, set in an artificial landscape designed by 'Capability' Brown to mimic natural scenery, stuffed with interiors by Robert Adam, furniture by Thomas Chippendale, and paintings by the likes of Joshua Reynolds, this perfect 'heritage attraction' encapsulates the unspoken

(sometimes, unspeakable) deal behind the splendour of the new, Georgian elite.

Edwin Lascelles, 1st Baron Harewood, was from an ancient gentry family (hence a French-looking name that English people will mispronounce if they aren't from the 'right' background) but what allowed him to rise to this glory, and eventually to be ennobled, was new money. That money, gained in trade, gave him entrance to the so-called Whig Oligarchy, who ran Britain for most of the 18th century.

No problem then? Surely social mobility is a healthy sign of a dynamic society? Well, yes – except that as with Russian oligarchs today, it was often unwise to ask exactly how the Whig Oligarchs had come by that new money. All too often the answer was – as it was in the case of Edwin Lascelles – that you really didn't want to know. The vast wealth which enabled Lascelles to build Harewood, stuff it with artistic treasures, and get his title, came from his West Indian sugar plantations, and from acting as banker to other sugar planters. It was all based on slavery.

The truth was that the Lascelles family made it by turning into slave-driving pushers of sugar. At once an appetite-suppressant and a livener (as still marketed in 'energy drinks'), cheap sugar would become central to the diet of the poor for the next 200 years, with drastic effects on their dentistry and their health. The price of this new drug was the enslavement of Africans by the million.

Still, who cared where your money came from, provided you stuck it, as the fashion demanded, into a socking great, brand-new, Roman-look house and had (like Edwin Lascelles) a picture of yourself by Joshua Reynolds over the fireplace? There was a good reason the discussion of 'trade' was forbidden in polite society.

Joshua Reynolds's most-hated rival, however, was less polite. He was ready to look at the grimy details of Georgian society – and to find a new kind of buyer for his art.

EXPLORE FURTHER | Edwin Lascelles by J. Reynolds, painting (late 18th c.; Harewood Hse.) • Paxton Hse., ext. by J. & J. Adam, int. by T. Chippendale (1758–95; Berwicks.) • 'Dancing Scene in the West Indies' by A. Brunias, painting (1700s; Tate)

Marriage A-la-Mode
William Hogarth | 1743–45

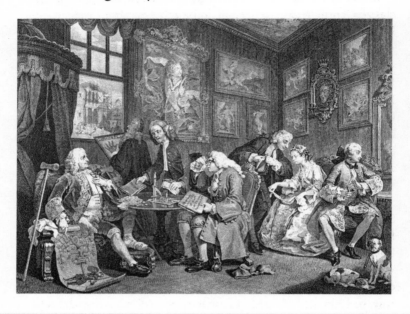

Hogarth's achievements are breath-taking. His art is always about lived reality on the streets of London. He is concerned to convey the vitality of his own world and to tell what he thinks of as the truth – the truth about corruption, the truth about London. It's an English art that is independent of the classical fantasies of Sir Joshua Reynolds.

VIC GATRELL

Instead of one-off pieces for the wealthy, Hogarth offered mass-reproduced pictures for the middle classes, drawn from the teeming streets and satirising the follies of the age, which his viewers instantly recognised. Technologically, this was cutting-edge stuff, but Hogarth had in fact rediscovered the medieval tradition of moral tales told in pictures stuffed with details, all meaning something to the viewer. Like stained-glass windows,

his art was designed to be accessible to everyone, to spark recognition, storytelling, and discussion.

In the first image from 'Marriage A-la-Mode' he skewers the classic Georgian deal between Old Nobility and New Money. The Earl of Squander (left) points proudly to his family tree, but in reality is threatened with the mortgage documents on his estate, which he has bankrupted in building the unfinished Harewood House-like neo-classical mansion in the window behind him. His salvation is the marriage settlement offered by the wealthy London Alderman, who peers through his glasses to make sure he's getting a good deal. The sad-looking daughter is encouraged by the pimp-like lawyer Silvertongue, while her future husband, already bearing the tell-tale signs of syphilis, regards himself vacantly in the mirror.

Small wonder that although Hogarth lived just across Leicester Square from Joshua Reynolds, the pair never spoke. For Hogarth had taken a completely different path to wealth and fame, one that by implication laughed at Reynolds's toadying. His problem was that anybody else could copy and sell his work – until he defended this modern creative business in a thoroughly modern way. In 1735, he led a group of fellow-practitioners in winning the 'Act for the Encouragement of the Arts of Designing, Engraving, Etching &c.', sometimes just known as 'Hogarth's Act'. It was the birth of modern copyright law and with it, British artists became businessmen overnight.

With his income-stream legally secured, Hogarth published the eight paintings known as 'A Rake's Progress', charting the downfall of a wealthy merchant's son who falls victim to the temptations of the metropolis. It was a vast success and Hogarth next took aim at the ruling class itself in 'Marriage A-la-Mode'.

Meanwhile, across the Irish Sea, in a land which shared its king with Britain but (in theory) still had its own parliament, another artist was confronting the hypocrisy of the elite with a different kind of satire.

EXPLORE FURTHER | 'A Rake's Progress' by W. Hogarth, paintings (1732–4; Sir John Soane Mus.) • *Gemma Bovery* by Posy Simmonds, graphic novel (1999) • 'The Vanity of Small Differences' by Grayson Perry, tapestries (2012; touring)

A Modest Proposal

Jonathan Swift | 1729

> INFANTS Flesh will be in Season throughout the Year, but more plentiful in *March*, and a little *before* and *after*, for we are told by a grave Author, an eminent *French* Physician, that *Fish being a prolifick Diet*, there are more Children born in *Roman Catholick Countries* about nine Months after *Lent*, than at any other Season : therefore, reckoning a Year after

We're still talking about *A Modest Proposal* today because it's the gold standard for how to go about this kind of comedy.

STEWART LEE

Jonathan Swift is best remembered today for *Gulliver's Travels*, but his hardest-hitting satire is about the state of Ireland. *A Modest Proposal* uses the classic trick of drawing people in by talking their own talk, until the vital moment. In Swift's day, the talk of the chattering classes was all about Rational Protestant Efficiency (aka making money). This principle was used to justify almost anything, from replacing your legitimate king with a German prince, to kicking your peasantry off the ancient common land, to clearing the Highlands, to enslaving Africans.

Swift could channel this Georgian elite because he was – almost – one of them. He belonged to the Protestant Ascendancy of Ireland, who dominated social and political life there. Like all colonists surrounded and outnumbered by potentially hostile natives (in this case, the Catholic Irish), they looked to their supposed homeland (in this case, England) as their ultimate,

military guarantor. Yet they were still of Ireland. When the English Parliament browbeat and bribed the Dublin Parliament into putting extra duty on Irish wool to benefit English competitors (1699), then took away its right to decide Irish laws (1717), some, like Swift, began to suspect that Britain was deliberately keeping Ireland locked into poverty. This painfully ambivalent position – British, yet actually Irish, or perhaps vice-versa – is what made him such an effective satirist of colonial Ireland.

He begins by appealing to fashionable Enlightenment notions. What should a rational person do, when faced with thousands of starving Irish children? Clearly, a mathematical scheme is needed!

> Instead of being a charge upon their parents, or the parish, or wanting food and raiment for the rest of their lives, they shall, on the contrary, contribute to the feeding, and partly to the clothing of many thousands.

Having suckered his readers in, Swift lands his killer punch: Ireland is in such a catastrophic state right now – thanks largely to England's destruction of its trades – that selling its children as food is nothing more than the next rational move:

> I have been assured by a very knowing American of my acquaintance in London, that a young healthy child well nursed, is, at a year old, a most delicious nourishing and wholesome food, whether stewed, roasted, baked, or boiled.

The outrage behind Swift's satire was plain. Soon, there would be people in Ireland ready to do more than satirise British colonialism – and in Britain itself, people were starting to stand up and be counted in a crusade against the most blatantly immoral of all rational Georgian money-making schemes: the slave-trade.

EXPLORE FURTHER | 'London: the Third Satire of Juvenal, Imitated' by Samuel Johnson, poem (1738) • *Erewhon* by Samuel Butler, novel (1872) • 'The Day Today' by Chris Morris & Armando Iannucci, BBC tv series (1994)

Anti-Slavery Medallion

Josiah Wedgwood | 1787

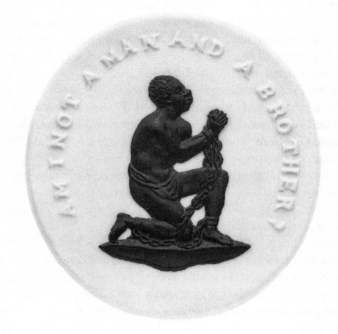

Wedgwood's politics were born of radical patriotism: a deep love of his country alongside a fearful sense that the promise of Great Britain – Liberty under the law, Protestantism and Progress – was being undermined by ministerial greed and jobbery.

TRISTRAM HUNT

In 1787, Josiah Wedgwood got his chief designer to create a medal small enough to wear as buttonhole, in your hair, on necklace or a bracelet, yet striking enough to carry its message loud and clear. Just like, say, the Extinction Rebellion (or for that matter, a MAGA) logo today, it served as an invitation or a warning: a public statement of the way you thought, and of your readiness to engage in argument. This extraordinarily modern

campaign was the brainchild of the man who more or less invented modern business.

Wedgwood sprang from the non-conformist Christian community most powerful in the Midlands and the North. To them, hard work, education, modest living and useful industry were moral, almost religious qualities, which set them apart from the hedonistic, hunting-and shooting, land-owning classes who ran the country. Refusing to accept the Anglican Church, they were banned from the universities, Parliament and the Law, so they turned their creative energies to R&D, and to trade.

Until Wedgwood, the finest china came, self-evidently, from China. European products couldn't compete. In the mid 1760s, he cracked the formula at last. And he knew how to shift his product as well as how to make it. Like some branding maestro today, he set up what we'd now call a Flagship Store in the West End, stocking his most exclusive items. The wealthy Londoners who flocked there little realised that he was using them as unpaid influencers to publicise his more mass-market goods. These in turn were sold to the aspirational public via mail-order catalogues, offers and a whole armoury of modern marketing strategies. Wedgwood became vastly wealthy and created thousands of jobs. His career raised the same questions we now ask about Gates, Bezos and Musk: what are their responsibilities towards the society that enabled them to innovate, take risks and grow rich? The anti-slavery medal gave a clear answer.

The campaign to abolish the slave trade took off. Four years after the Medallion appeared, in 1791, William Fox published his *Address to the People of Great Britain, on the Propriety of Abstaining from West Indian Sugar and Rum*. Some 200,000 copies were distributed, headlining a national sugar boycott, known as 'anti-saccharrism.'

But was this all just 'virtue-signalling' by comfortable white Britons? The most vicious cartoonist of the age, a man still looked up to by his profession today, couldn't resist asking the question.

EXPLORE FURTHER | Abolitionist wares (18th c.; World of Wedgwood, Stoke-on-Trent.) • Suffragette collections (early 20th c.; Mus. of London) • Dagenham Ford Sewing Machinists Strike Commem. Plate (1984; People's History Museum)

Anti-saccharrites

James Gillray | 1792

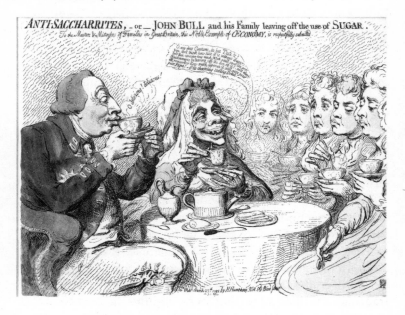

The 18th century is seen as the age of reason. But there is an open sewer of satire running through it, from Swift, via Hogarth, up to Gillray.

MARTIN ROWSON

Where William Hogarth gave his audience panoramic satires, peopled by characters representing the broad social types and human foibles of Britain under the Whig Oligarchy, James Gillray (who had studied Hogarth deeply) hit on something very different. He offered tight focus on a single topical event, based around unmistakable, if grotesquely exaggerated, portraits of recognisable, living figures, complete with speech balloons that mimicked the real person's language. In doing so, he practically invented the modern political cartoon.

He was in the right place at the right time. By the 1780s, the Whig hegemony had crumbled and Westminster rang with the vicious party warfare and personal insults that we today know all too well, so having a great satirist on your side was invaluable. In 1797, the Tory government even awarded Gillray a secret grant to keep him onside. But he wasn't on anyone's side. He was essentially populist, a gloomy alcoholic ready to attack anyone about anything to ensure notoriety, and thus sales. In 1791, the campaign to boycott sugar and cripple the slave trade was all the rage, so Gillray quickly published 'Barbarities in the West Indies', graphically mocking the brutality of slave-owners. When the Royal Family themselves took up this fashionable cause, however, he couldn't resist the chance to laugh at their pious gesture politics.

The six royal daughters are encouraged by King George III and Queen Charlotte to give up sugar from the West Indies. But Gillray shows the princesses hating the taste of their newly-virtuous tea. He puns on the double meaning of 'save', suggesting that the king is actually more interested in cutting back on domestic expenses than helping to abolish the slave trade. Queen Charlotte says to her daughters, 'You'll save the poor Blackamoors by leaving off the use of it! And above all, remember how much expense it will save your poor Papa!'

Clever and funny. In the end, though, isn't satire itself just another kind of virtue-signalling? By saying that everything has its funny side, you can have your cake and eat it, seeming radical but actually standing for nothing. By the time Gillray made that drawing, satire was starting to feel like far too little. In 1789, the year the French Revolution exploded, a great cry for liberty was published in London, not from well-meaning white opponents of the slave trade, nor from a clever satirist, but from one of the victims. For the first time, a black Briton was putting the writing on the wall.

EXPLORE FURTHER | 'The Plumb-pudding in Danger' by James Gillray (1805; BL) • 'The Price of Petrol has been increased by One Penny' by Philip Zec, cartoon (1942) • Various cartoons by Steve Bell (1979–; www.belltoons.co.uk)

The Interesting Narrative of the Life of Olaudah Equiano *or* Gustavus Vassa, the African

Olaudah Equiano | 1789

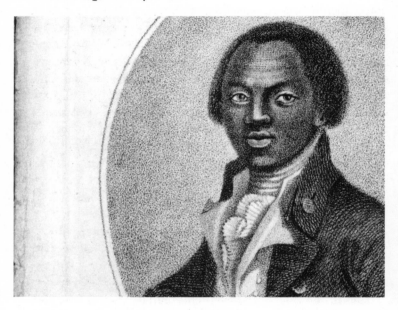

> In Hogarth, we are the servants, we sit on the edge. In Gillray, we are the victims. We're always voiceless. But Equiano has a voice.
>
> GUS CASELY-HAYFORD

Olaudah Equiano was captured on the West Coast of Africa and sold into slavery in the Caribbean. Luckily, he became a household servant rather than a labourer, and worked his way up through different jobs until he bought his own freedom. He came to England, a safe haven for ex-slaves thanks to Somersett's Case (1772). Therein the Lord Chief Justice declared slavery to be so 'odious' and 'so high an act of dominion' that it must be recognised by the law of the country'. In other words, slavery

could only be legal if a law postively made it so. Without such a law, it was illegal and in England, the slave, James Somersett, was a free man. This decision marks a great shift in sensibility. If in doubt, the Law no longer came down on the side of rational efficiency or property rights, but was guided by natural morality.

Britain's slave-colonies were not legally part of Britain, so the Lord Chief Justice's rulings did not apply there, nor did it end the slave-trade. Yet in the story of these islands it is vital, because it in effect established that the Law here was colour-blind. However racist social attitudes in Britain might be (and they grew more so over the next 150 years, as racist pseudo-science was invented and accepted), black people in Britain never lived under laws which enshrined and justified racism. That is one of the most profound differences between our story and that of America.

So, even as the French were overthrowing their ancient monarchy, Equiano was able, in London, to throw his own voice into a cause that was winning the day:

> Surely this traffic cannot be good, which spreads like a pestilence and taints what it touches... The closeness of the place and the heat of the climate added to the number in the ship, which was so crowded that each had scarcely room to turn himself, almost suffocated us... The shrieks of the women and the groans of the dying rendered the whole a scene of horror almost inconceivable.

His novelised testimony – authentic, lived, and for that reason much more potent than satire – was a powerful weapon in the battle against slavery. It was also part of a wider, subliminal cultural struggle against the London-based, mercantile-rational monoculture of Georgian Britain. And in Scotland, since the last revolt of 1745 seemingly just another place within a Westminster-ruled island, a passionate new voice was saving what could be saved of a separate identity.

EXPLORE FURTHER | *Letters of the Late Ignatius Sancho, an African* (18th c.; BL) • 'Head of a Man' by John Simpson, painting (1810; Tate Britain) • Statue of Olaudah Equiano by pupils of Edmund Waller School (2008; Telegraph Hill)

A Man's a Man for A' That

Robert Burns | 1795

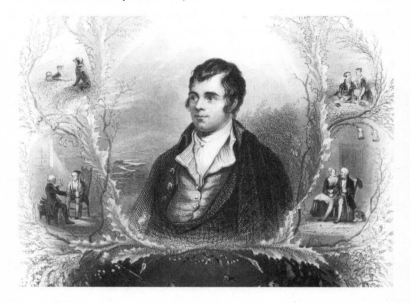

It's a little fragment of bar-room philosophy, almost. It says, in ordinary language, something quite fundamental, something humanistic, something which is actually very much part of the Scottish Enlightenment way of thinking.

JOHN MULLAN

On 1st July 1999, when Scotland opened its first national Parliament since 1707, the words sung were those of a man born into rural poverty 240 years ago before. But no ordinary man. Robert Burns wrote one of the best-known songs on Earth – 'Auld Lang Syne' – among many others. Romantic German nationalists of the mid 19th-century loved him. He was celebrated in the Soviet Union as the great poet of the workers of the world. No creator, however individually brilliant, achieves that kind of worldwide reach without being part of something bigger, whether they know it consciously or not.

In 1746, just thirteen years before Burns was born, Highland Scotland, having terrified London, was put to the sword at and after Culloden. He was thus the child of a people still suffering the aftershocks of epochal defeat. What we'd now call ethnic cleansing – the Highland Clearances – was designed to change Scotland into just another loyal and useful part of Great Britain, if an agreeably colourful one: the Scottish tourist industry was born in 1773, when Dr Johnson made his famous tour through the Highlands. By that time, Burns was a teenager, already writing his first poems. Clearly, if he wanted to give a voice to his defeated people, yet make a living as a word-smith under the new dispensation, he had to take up a very careful position.

Burns's dilemma, and his solution, were rather like those of the first nationally successful black musicians in early 20th century America: like them, he wrote not of overt suffering and subjugation, which would have been both too threatening and too painful, but of love, of nostalgia for a vague, lost, better past ('Auld Lang Syne') and of a longing for common humanity ('A Man's a Man'); like them, he employed passionate language that was exotically different froi normal English, yet could still be understood; like them, he made the deep trauma of a people appear safe and sentimental.

> What though on hamely fare we dine,
> Wear hoddin grey, an' a that;
> Gie fools their silks, and knaves their wine;
> A Man's a Man for a' that

The combination was irresistible. When hundreds of millions of people sing his words every New Year, they are confirming, yet again, that it really is all about the way you tell it.

Meanwhile, in the London that was welcoming Burns's songs, a woman was, at last, telling it as it was, for women. And like Burns, she had to work within what was allowed.

EXPLORE FURTHER | The poems of Ossian by James Macpherson (1760s, but provenance disputed) • *A Journey to the Western Isles of Scotland* by Samuel Johnson (1775) • *Poems Descriptive of Rural Life and Scenery* by John Clare (1820)

A Vindication of the Rights of Woman

Mary Wollstonecraft | 1792

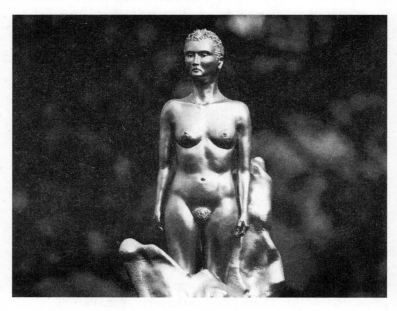

She challenged everything around her. The sculpture refers to the history and the struggle of women, and it's also rather sexy. I hope it's a metaphor for the spirit of Mary Wollstonecraft.

MAGGI HAMBLING

Mary Wollstonecraft was, in the words of her own husband, 'not formed to be the contented and unresisting subject of a despot'. She was absolutely committed to the cause of freedom for women, and she lived it. Yet no radical spirit can have impact unless it garners echoes in its world. Wollstonecraft had to win over the opinion-formers of Georgian Britain: the modernising, middle-class, non-conformists. Their buzz-words were family, virtue and rationality (as opposed to aristocratic licentiousness, corruption and capriciousness). So, consciously or unconsciously, she had to talk their talk:

chastity must more universally prevail, and that chastity will never be respected in the male world till the person of a woman is not, as it were, idolized... [men] have been more anxious to make them alluring mistresses than affectionate wives and rational mothers.

In words that are still challenging today, Wollstonecraft declared that women had to change themselves:

Rational men will excuse me for endeavouring to persuade women to become more masculine and respectable... Women are, in fact, so much degraded by mistaken notions of female excellence... those contemptible infantile airs that undermine esteem even whilst they excite desire.

At Newington Green in North London, there stands a controversial sculpture to her memory, near where she founded her own school for girls, aiming to create new women, ready to change the world.

And change was everywhere. For 250 years, the powerhouse of southern England had tried to turn everybody into Protestant English. In 1798 came the sign it hadn't worked as Ireland rose in bloody rebellion. Order was restored with astonishing brutality, and on 1 January 1801, yet another new 'us' was created: the United Kingdom.

Now almost a third of us were Catholics and at least a quarter of us (the large majority in Ireland, most people in Wales, and a large minority in Scotland) couldn't speak English, never mind read or write it. The new UK was a truly multicultural, multilingual state – and it worked brilliantly. Having defeated Napoleon, it extended its Empire, and its culture, wider still and wider. Its birth out of war and rebellion is the background to the work of a woman whose books are still read – and misunderstood as cosily safe – around the world.

EXPLORE FURTHER | Mary Wollstonecraft by John Williamson, painting (1791–2; Walker Art Gallery, Liverpool) • *Frankenstein* by Mary Shelley (1818) • Wollstonecraft Memorial by Maggi Hambling, sculpture (2020; Newington Green)

Mansfield Park

Jane Austen | 1814

Ignore its uptight reputation – *Mansfield Park* seethes with sex, and explores England's murkiest corners.

PAULA BYRNE

Jane Austen's works only seem tame because they are so familiar. It took the BBC's daring 1995 'Pride and Prejudice', Colin Firth's wet breeches and all, to remind us she is writing about a world in which instinctive and immediate sexual desire can be at war with the demands of social position. Her third novel, *Mansfield Park*, is still more riddled by these tensions.

The very first paragraphs are packed with unspoken meanings. Austen hints that her heroine, Fanny Price (you couldn't make it up) has inherited a potent female sexuality which is attractive to men, but liable to run wild. Her aunt

has snared a far richer man, Sir Thomas, while her mother wilfully married a poor, useless Lieutenant. As soon as Fanny's aunt proposes that she should come to live with them, Sir Thomas is worried. Austen's weird, clammed-up punctuation suggests literally unspeakable depths: 'He thought of his own four children, of his two sons, of cousins in love, etc.;--' Her readers would have understood. Unlike the Victorians (see 'A Child's World'), the Georgians didn't see childhood as a rosy time of innocence. Though the penniless Fanny is only ten, she – with that parental history! – might be a fatal temptation for Sir Thomas's wealthy sons (he's right: one of them ends up marrying her). That 'etc.' hints at the wider picture: the estate of Mansfield Park which, as the title suggests, is what really matters to everyone. From the start we are told, and then reminded throughout, that it's underpinned financially by 'Sir Thomas's West Indian property'. Austen doesn't go into further detail because she doesn't have to. Everyone in 1814 knew exactly what 'West Indian property' meant.

Here, just as in *Pride and Prejudice* (where the family comes perilously close to social ruin thanks to the youngest daughter's inability to resist a handsome but penniless soldier), Jane Austen's world is anything but a fancy-dress heritage tea-party. It's a world at war, filled with social and sexual threats which are only just kept in check. It's as if she intimated that after her, a deluge was coming.

And come it did. The year Austen left off her last, unfinished novel, *Sanditon*, and died, another woman, Mary Shelley, daughter of Mary Wollstonecraft, wrote a story so different it seems to come from another universe: *Frankenstein*. A mighty storm was bringing the greatest change in human society since people swapped hunter-gathering for farming. And it was making landfall on these very islands. We were about to become the very first lab-rats of a brave new industrial, urban world.

EXPLORE FURTHER | *Emmeline* by Charlotte Smith, novel (1788) • *Pillar to Post* by Osbert Lancaster, book of drawings (1938) • 'Pride and Prejudice', BBC TV series (1995)

6. RISE
OF THE CITIES

Rain, Steam and Speed

Cyfarthfa Ironworks Interior at Night

Rural Rides

North and South

Alexander 'Greek' Thomson's Buildings

Idylls of the King: photographs

Proserpine

William Morris Wallpapers

Goblin Market

A Child's World

The Picture of Dorian Gray

Camden Town Nudes

In the 19th century, the United Kingdom became the most extraordinary imperial culture since Rome.

A new wave of boarding-schools created the Public School Men. In private, they might move in very different circles, but in public they carefully acknowledged one another as members of the same ruling order, be it in Mayfair or Madras. Their sports, manners, dress, and architecture – and their investments – spread across the globe.

It did little good to many ordinary people. The populations of Ireland and Highland Scotland fell, as vast numbers fled to the US or the colonies. Rural England and Wales, too, were locked in grinding poverty. Millions left the land and became the first people on Earth to experience modern, urban, industrial life.

It worked – for some. National wealth sky-rocketed. The world's first consumer society was born. More men got the vote. But at the end of this apparently glorious century, the Boer War (1899–1902) rocked the Empire. The Army, catastrophically defeated in the opening weeks, desperately called for manpower, only to find that in Imperial HQ itself, thousands of patriotic, fighting-age volunteers were just too badly-nourished and unhealthy to make any kind of soldiers.

This was the wildly contradictory new version of us – mighty across the world, yet troubled at the core – that shocked or inspired artists to create the first true visions of modernity.

Rain, Steam and Speed

J. M. W. Turner | 1844 | National Gallery

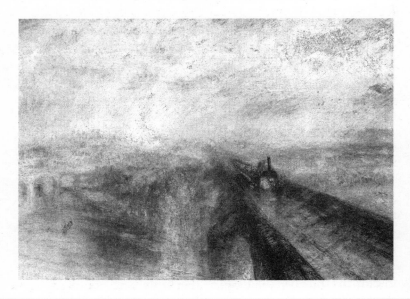

Great Britain was the first country in the world to experience all
the wonder, the excitement, the division, the conflict of a mass
urban industrial society.

TRISTRAM HUNT

In 1844, J.M.W. Turner (1775–1851) painted a train crossing a
viaduct. Which tells us absolutely nothing. It isn't just that the
painting is clearly non-realistic. Spectacular, lasting art is rarely
about what it seems to be about: to understand it, you need
to understand the age in which it was born. Turner's vague,
dissolving world seems to embody Karl Marx's famous dictum
(set down just four years later): 'All that is solid melts away'; the
picture was first shown during the 'Railway Mania' of 1843–5,
when people threw money at all and any railway company
shares, with no thought of the realistic financial prospects,
much as they throw money at crypto today.

So what do we actually see? A machine blasts out from a singularity of white light which could almost portray Genesis 1:3 or the Big Bang: the dawn of matter itself out of pure energy. It races toward us over a viaduct which seems more ancient than modern, an outcrop of natural rock, hovering over a gulf of nothingness. The thunderous journey is guided only by barely-visible rails, with no sign of a human driver, and only the feeblest of lamps. Within seconds, it will hurtle on past us, carrying its load of dimly-seen passengers, exposed to the naked elements, out of the picture and away into darkness.

Down on the left, near an old road-bridge (whose fastest traffic in 1844 would have been horse-drawn carriages), a fishing boat heads in the opposite direction to the train. On the right, a ploughman and his horse are also going that way. Trace the lines along which these ancient forms of movement, work, and power are travelling: bridge, plowman and boat would meet in the white light from out of which the train has rocketed – as if the past is being sucked into that singularity. Beneath the viaduct dances a mysterious group of classically-dressed girls; and in front of the thundering train flees that famous, now almost invisible hare, classical symbol of natural fertility.

This isn't a realistic picture of a train crossing a viaduct. It's a vision of a civilisation which has unleashed godlike – or perhaps demonic – powers, speeding unstoppably towards an unknown future where nature itself might be run down.

The impact was most profound in places where geology had always been unfriendly to agriculture, but bore the vital minerals which this new civilisation devoured. Handy deposits of coal, ore and limestone transformed an obscure Welsh mountain hamlet named after a fifth-century Christian martyr – Merthyr Tydfil – into the greatest iron-making town on Earth. A local artist dutifully recorded the awesome new logistics of this modernity – but also, in a less careful moment, noted its looming tensions.

EXPLORE FURTHER | 'Night Train' by David Cox, watercolour (ca. 1849; Birmingham Museum and Art Gallery) • *Middlemarch* by George Eliot (1871–2) • 'Adlestrop' by Edward Thomas, poem (ca. 1917)

Cyfarthfa Ironworks Interior at Night

Penry Williams | 1825 | Cyfarthfa Castle Museum

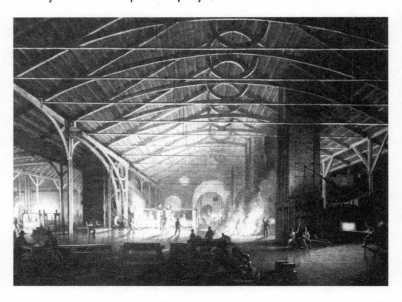

This picture is a rare window into industrial methods from the time before photography. It's very much a realistic painting.

CHRIS PARRY

Realistic? Up to a point. The tale of Penry Williams (1802–1885) shows the balancing act any artist has to make between what they see, and what people will buy. Here, in gentle watercolours, is a vibrant yet orderly scene of wealth-creating, go-ahead industry. The commission came from the great local iron-master William Crawshay II, who (being paymaster) got a picture which gave the impression of almost cathedral-like grandeur, yet could pass among his friends as a realistic depiction of his world-beating ironworks. Another side of reality was nowhere to be seen.

Merthyr Tydfil was notorious as a wild boom-town with practically no laws at all, never mind health and safety

regulations. It was different from the industrial north of England in one vital respect: despite massive immigration by job-seeking English and Irish, most people's first language was still Welsh. This gave an extra cultural edge to the thorny industrial relations of the Victorian UK (after all, the very place that led Marx and Engels to believe that a world revolution was scientifically inevitable). In England, workers might strike and even riot – but in South Wales, able to plot secretly in their own language and seeing the bosses as essentially foreign, they might actually take up guns, as they did in Merthyr six years after Williams painted his orderly scene.

> They were addressed by several of the iron-masters present at the inn, both in English and Welsh, but without effect ... the villains were observed from the tower of Cyfarthfa Castle exercising in line with the sabres and pistols taken from the cavalry.
>
> NEWGATE CALENDAR (1831)

It wasn't that Penry Williams didn't know this. In 'Merthyr Riots', an early picture from 1816, before he had been 'discovered' (that is, trained up and hired), he had shown serried ranks of redcoats – the same formations that had won at Waterloo just a year before – marching to put down the rebellious workers of South Wales. By the time of the 1831 riots, however, partly thanks to Crawshay's patronage, he had been able to leave South Wales and settle in Rome, there to live out his (secretly gay) life as a successful purveyor of steadfastly generic paintings to prosperous Victorians. After all, who wanted pictures of redcoats quelling riots?

But wait. If things were really so bad for workers in early industrial Britain, why did people flock there? The answer was given in memorable terms by one of the great media personalities of the age, William Cobbett.

EXPLORE FURTHER | 'Merthyr Riots' by Penry Williams (1816; Cyfarthfa Castle Museum) • 'Welding a Cylinder' by Maurice Broomfield, photo. (1935; V&A) • 'Six Bells Colliery, Abertillery' by L.S. Lowry, painting (1962; Nat. Mus. Wales)

Rural Rides

William Cobbett | 1822

Part of Cobbett's radical agenda is that Britain needs to look after its working class, above and beyond caring about abolition elsewhere.

FARIHA SHAIKH

William Cobbett raised an impassioned cry about the passing of sustainable peasant life. Enclosures had finally transformed rural England into the well-ordered landscape which we now call 'traditional'. As a result, there was now almost no significant common land left in the country. Such land had always been vital to the survival of the peasantry, because on it you could keep pigs, forage for game, mushrooms and berries, seek out medicinal herbs, or gather fuel by right of timeless custom (much of this work, some of it demanding serious, handed-down knowledge, was done by women, so the enclosure of common land was a particular blow to their earning-power and status). With that ancient resource gone, peasants were wholly at the mercy of a new landlord class.

On his *Rural Rides*, Cobbett found that any notions of *noblesse oblige* towards tenants had been abandoned. The great landowners were now no longer true countrymen but wealthy *arrivistes*, the 19th-century equivalent of today's 'Chipping Norton set':

> A gentry, only now-and-then residing at all, having no relish for country-delights, foreign in their manners, distant and haughty in their behaviour, looking to the soil only for its rents, viewing it as a mere object of speculation… generals, admirals, governors, commissaries, contractors, pensioners, sinecurists, commissioners, loan-jobbers, lottery-dealers, bankers, stock-jobbers.

Cobbett here is not talking about Irish peasants, poor Highlanders, or the subject peoples of India, but about rural labourers in Cricklade, Oxfordshire, in the late 1820s:

> The labourers seem miserably poor. Their dwellings are little better than pig-beds, and their looks indicate that their food is not nearly equal to that of a pig. Their wretched hovels are stuck upon little bits of ground on the road side… In my whole life I never saw human wretchedness equal to this: no, not even amongst the free negroes in America.

This life-sapping rural poverty made the industrial revolution possible: however dreadful conditions in the new, northern industrial cities might be, they were better than being a labourer in southern England. The result was a great transfer of population, wealth and power from south to north. The Chartist movement for radical electoral reform called its very own newspaper the *Northern Star* with good reason. After briefly scaring Westminster half to death with a 'Monster March' in April 1848, the Chartists, backed by none other than Karl Marx himself, even tried setting up an alternative Parliament in the new capital of the North: Manchester.

EXPLORE FURTHER | *The Pickwick Papers* by Charles Dickens (1836) • *The Road to Wigan Pier* by George Orwell (1937) • Shelter archive of photos. by Nick Hedges (1968–72; National Science and Media Museum, Bradford)

North and South

Elizabeth Gaskell | 1854

Manchester is about money, international trade, goods coming in, manufactured items going out across the globe. But behind all that, street after street after street of poverty.

RUTH LIVESEY

In *North and South* by Elizabeth Gaskell, a middle-class southern Englishwoman has to relocate to Milton (a thinly disguised Manchester):

> Quick they were whirled over long, straight, hopeless streets of regular-built houses, all small and of brick. Here and there a great oblong many-windowed factory stood up, like a hen among her chickens. Every van, every waggon and truck bore cotton…
>
> 'I've never been right since I began work in the carding-room, and the fluff got in my lungs and poisoned me,' said Bessy.
>
> 'Fluff?' said Margaret, inquiringly.
>
> 'Fluff,' repeated Bessy. 'Little bits as fly off fro' the cotton, that fill the air 'til it looks all fine white dust. They say it winds round the lungs and tightens them up.

One worker thinks about fleeing to the south. But Margaret (who has seen the sort of poverty described by William Cobbett) puts him right:

> You could not stand it… The hard spadework robs their brain of life; the sameness of their toil deadens their imagination; they don't care to meet to talk over thoughts and speculations, even of the weakest, wildest kind, after their work is done; they go home brutishly tired, poor creatures! caring for nothing but food and rest. You could not stir them up into any companionship, which you get in a town as plentiful as the air you breathe.

The things which draw people to cities today, in spite of pollution and crime, drew them to the industrial cities of the early 19th century in spite of bad diet and a toxic environment: physically light, indoor work, regular cash wages, and above all other people to 'talk over thoughts and speculations'.

One of the great speculations of the day was how to maintain national unity in the face of this muscled-up northern England, with its industrial culture and non-conformist leanings. In 1851, the Rev. Nathanial Woodard founded a great wave of new public schools aimed at turning the middle classes of the north into southern-style, Anglican gentlemen.

> We in the south cannot realise the state of society. Dissent is not in any painfully obnoxious form here, nor are morals flagrant. To see it in the north, in the manufacturing districts, makes one shudder… Our system of large public schools will quite alter the tone of the middle classes.
>
> MORNING CHRONICLE, NOV. 1851

Education was one way to cultural unity. That same year, the philosopher-architect Sir Gilbert Scott proposed another: a grand national re-branding. But not everyone agreed.

EXPLORE FURTHER | *Shirley* by Charlotte Brontë (1849) • 'Weaving Sheds, Howarth's Mills' by H.E. Tidmarsh, painting (1893–94; Manchester Art Gall.) • 'Mill Girls, Ashton, Lancs.' by H. Rutherford, painting (1948; Astley Cheetham Art Gallery)

Alexander 'Greek' Thomson's Buildings

Mid 19th c. | Glasgow

He was practising in the Greek style at a time when the country was in the thrall of the Gothic.

FIONA SINCLAIR

In Glasgow, Alexander 'Greek' Thomson (1817–1875) stood almost alone against the Victorian architectural pack. Their guru was Sir Gilbert Scott, creator of neo-Gothic icons like St Pancras Station and the Albert Memorial, who announced in 1851 that what the nation really needed to unite it, in the face of modernity and regional splits, was:

a new and vigorous style upon the foundation of the glorious architecture of our own country and forefathers, in the place of one at once alien to our race and our religion.

In other words: we could almost literally plaster over the problems of the industrial age by pretending we lived in the Middle Ages. And so, under the new public-school men, the British Empire began throwing up Gothic buildings as inevitably as the Roman Empire had thrown up columns.

Perhaps being in Scotland, on the brink of the first modern calls for Home Rule, helped Thomson resist London's cultural instructions. Instead of a neo-Gothic fantasy world in which the tensions of modern society could be neatly sidestepped, he proposed to leap straight from classical models into a future where architects would embrace modernity head-on and, within it, find creative ways to make the new urban way of life fully human. His signature tenement buildings don't deny the need for high-density living, but fulfil the need for fresh air and light as a design priority. It's this embracing of the future which made *The Journal of the Society of Architectural Historians* declare in 1998 that 'there is something wildly "American" about Thomson.'

The country was not ready for it. Most men, never mind all women, were still unable to vote. Church and chapel attendance was not yet in decline, and still decided most people's beliefs and morals. You still couldn't study anything at Oxford or Cambridge unless you had both Latin and Ancient Greek. Even a creator like Thomson, whose work seems at times to be on the edge of 20th-century tech-driven modernism, still had to pay lip-service to the idea that any thoughts about the future, however radical, must be validated by references to the past.

This was even true of the most revolutionary and technologically innovative of all Victorian art-forms, the one which would come to dominate our modern world like no other: the art of drawing with light.

EXPLORE FURTHER | Abbotsford, home of Walter Scott (1811–1830s; Scottish Borders) • Holmwood House, des. by Alexander Thomson (1857–8; Glasgow) • The Lighthouse, des. by Charles Rennie Mackintosh (1899; Glasgow)

Idylls of the King: photographs

Julia Margaret Cameron | 1874

What makes Cameron's photography unique is that she sees
photography as high art.

JOHN HOLMES

When Alfred Lord Tennyson approached Julia Margaret Cameron (1815–1879) for photographs to illustrate a new edition of his most popular work, the Arthurian fantasy *Idylls of the King*, she jumped at the chance. 'It is immortality to me to be bound up with you,' she replied to the poet.

The curious result is that, although Cameron was one of the first to dedicate herself to the radical new artistic medium of photography, she is now chiefly remembered for blatantly staged scenes from a Victorian Gothic fantasy world. But every artist has to make their way within the existing world, even if they are ultimately heading somewhere new. To prove the worth of her new art, Cameron had to produce creations that the Victorian public would recognise beyond doubt as *Art*.

In any case, few had understood that photography would issue a life-and-death challenge to painting. The doyen of Victorian art criticism, John Ruskin, happily called it 'the most marvellous invention of the century'. Painters didn't see early photography as the enemy because it had such limitations. The emulsions couldn't reproduce small detail. The depth of field was very small. Exposure times were gigantically long: the strange, unfathomable expressions on the faces of Cameron's sitters are partly due to the simple fact that they had to stay rock-still for ten seconds or more. Her husband, one of her models, is said to have ruined several plates by lapsing into giggles. Finally, of course, early photography was exclusively black-and-white – or rather, shades of grey.

Surprising as it may sound, the radical young men on the mid-Victorian artistic block saw photography as a sort of party-trick which showed the way back to the future. If a mere machine could do it, why should painters bother with it? Instead, true artists should re-dedicate themselves to the things only real painting could do: super-fine detail, high dramas of the heart, and no-holds-barred use of colour. They called themselves the Pre-Raphaelite Brotherhood.

EXPLORE FURTHER | 'Girl holding the portrait of a man' by Ross & Thomson, photo. (1840–55; Nat. Mus. Scot.) • *Morte d'Arthur* by Alfred Tennyson, from *Idylls of the King* (1856–7) • 'Charles Darwin' by Julia M. Cameron, photo. (1868; NPG)

Proserpine

Dante Gabriel Rossetti | 1874 | Tate Britain

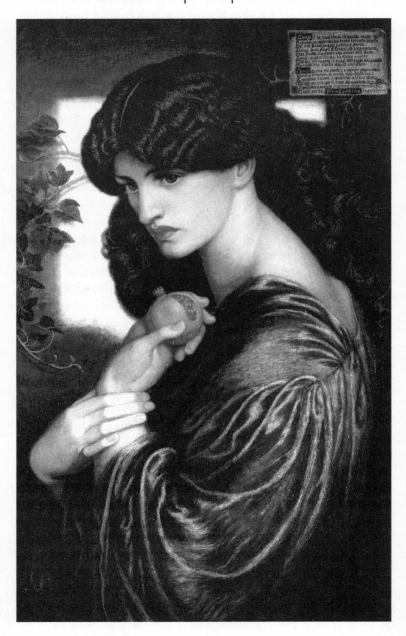

In some ways the Pre-Raphaelites were very modern but it's difficult to get around the fact that men are the gazers in these paintings and women are those that are looked at – a power dynamic in which the woman is passive. They are a *brotherhood*.

RHIAN WILLIAMS

The woman holds a fruit whose sexual hint is clear, and seems to be pondering her next move. Maybe that's why William Morris suggested that Dante Gabriel Rossetti (1828–82), his friend, house-mate and fellow Pre-Raphaelite, should use Morris's wife, Jane, as his model: she was also Rossetti's lover, apparently in control of the three-way relationship.

But if you know the myth, it's impossible to see this as an image of female power. Proserpine is kidnapped by Pluto, King of the Underworld. To save the world from eternal winter, Jupiter has struck a deal with his fellow-god, by which Proserpine will spend half of every year in the underworld as Pluto's consort, to be allowed back to the upper world for the other half. She is trapped in an arrangement between two male deities.

Jane Burden was discovered by Rossetti and Morris as one of their 'stunners' – beautiful working-class girls. From one perspective she can be seen as the first modern supermodel, a figure of liberation: her wild hair, almost masculine beauty and flowing clothes were extraordinary at the time; and by taking Morris's name in marriage, she freed herself financially and socially. Yet her freedom to love while remaining 'respectable' depended on Rossetti and Morris's agreement. In the end, like Proserpine, she was the subject of a male deal.

Perhaps uncoincidentally, the two men fell out soon after 'Proserpine' was painted. Rossetti moved away, though Jane continued her relationship with him, while Morris threw himself into the work for which he is remembered.

EXPLORE FURTHER | *Proserpine* by Mary Shelley, play (1820) • 'In an Artist's Studio' by Christina Rossetti, sonnet (1856) • 'Medea' by Frederick Sandys, painting (1866–8; Birmingham City Museum and Art Gallery)

Wallpapers

William Morris | 1860s–1890s

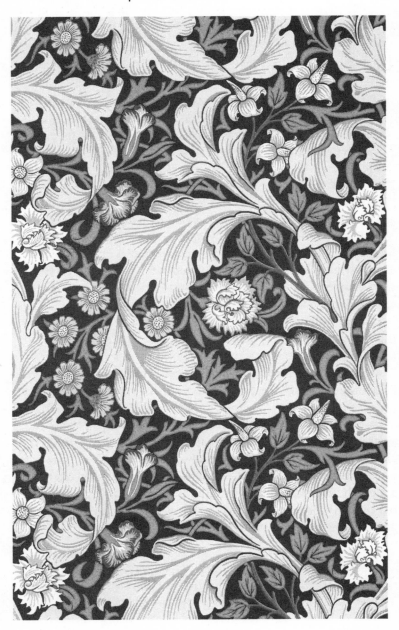

> It's not just a picture in a frame, it's an installation... Morris was attacking the Industrial Revolution with beauty – that's his sword.
>
> JEREMY DELLER

Morris, having failed to impress the public as a painter or poet, became instead the champion of the allegedly 'lesser arts' (as the title of one of his lectures put it).

> Nothing can be a work of art which is not useful . . . what tons upon tons of unutterable rubbish pretending to be works of art in some degree would this maxim clear out of our London houses, if it were understood and acted upon.

You can hardly miss the tone of gleeful vengeance upon the 'high art' world that had spurned him, while accepting such as Rossetti.

Morris's extraordinary wallpaper designs offered to turn the interiors of any middle-class home into an oasis of hand-made escape from the endless industrial, red-brick monotone, coal-soot-covered urban world outside – and into a sort of gallery, expressing the owner's culture and taste.

Oscar Wilde was also busy proclaiming that even people on modest incomes, if they followed the right aesthetic maxims, could have their very own House Beautiful (Wilde actually 'borrowed', i.e. stole, from some of Morris's lectures). The difference was that Morris made and sold the stuff too, as the first modern mass-market interior design guru.

As ever, though, there can be a vast difference between what a creative genius intends, and what they ultimately create. Morris claimed that his designs were a celebration of individual crafts-manship, but to us the luxuriant, sinuous, organic forms seem a pre-echo of the insights which Sigmund Freud would soon be offering: that beneath the bright lights and clean lines of the new age, our lives are still governed by ancient, unconscious desires.

EXPLORE FURTHER | Pomegranate wallpaper by Hugo Goes (1509; V&A) • Wall-papers by Thomas Willement (1820s–30s; Oxburgh House) • Wall of Sound by Maya Ramsay (2015; Hendrix/Handel House, 23 Brook St., London)

Goblin Market

Christina Rossetti | 1862

On the surface, it appears very simple. Two young girls, sisters, hear the fairy cries of the goblin men, tempting them and luring them with their astonishing catalogue of exotic fruits. But they know that they mustn't eat the fruit of the goblin men.

RUTH LIVESEY

L ike so many successful radical artists, Christina Rossetti (1830–94) deployed the ancient trick of the Trojan horse, its hidden and explosive cargo so well-disguised that it could be welcomed into their homes by respectable folk. Her most famous poem awoke no alarm bells in careful Victorian parents because it seemed to be saying exactly the right sort of thing. The heroine, Lizzie, was surely the perfect example for any young Victorian girl, standing firm 'like a rock of blue-vein'd stone' against the temptations of the goblin market.

'No,' said Lizzie, 'No, no, no;
Their offers should not charm us,
Their evil gifts would harm us.'

She thrust a dimpled finger
In each ear, shut eyes and ran:

Her 'curious sister', Laura, though, gives into the wicked offers.
Using a lock of her own hair as money, she buys the goblins' fruit,
gobbles it, and then never sees them again. Her innocence gone,
they no longer call to her, and she begins to wither away out of
longing for that forbidden fruit. Eventually, Lizzie goes down
to the goblin market on a rescue mission whose logic is never
explained. By some alchemy, her successful resistance to the
deeply physical and disturbing attempts of the goblins to make
her open her mouth and take their fruit, awakens a strange power
within her. She hurries back to Laura:

She cried, 'Laura', up the garden,
'Did you miss me?
Come and kiss me.
Never mind my bruises,
Hug me, kiss me, suck my juices
Squeez'd from goblin fruits for you,
Goblin pulp and goblin dew.
Eat me, drink me, love me;

Laura is saved and we fast-forward to a future in which the
girls have settled down to married respectability and children. To
Victorians, it appeared to be a moral parable about a good girl
who resists the temptations of the world, and thereby saves her
sister for the approved sort of life. To us, the extraordinary sense
of children trapped in a zone of total war between toxic male lust
and electric female sensuality is impossible to overlook.

Rossetti's apparently nursery-safe poem is in fact cross-
questioning in the deadliest manner the Victorian obsession
with childhood innocence. That obsession was so strong that if
an artist played it right, it could make them wealthy.

EXPLORE FURTHER | 'The Girlhood of Mary Virgin' by Gabriel Dante Rossetti, painting (1848–9; Tate Britain) • *Cautionary Tales* by Hilaire Belloc, poems (1907) • *The Oxford Dictionary of Nursery Rhymes*, ed. Iona and Peter Opie (1951)

A Child's World

John Everett Millais | 1886 | Lady Lever Art Gallery

You could say that 'Bubbles' is a Pandora's Box moment – that it heralds a new era when the image takes on a life of its own, independent of its producer.

<div align="right">

ALISON SMITH

</div>

In 1886, John Everett Millais painted, 'A Child's World', a portrait of his cherubic grandson that at first sight seems to be all about carefree childhood innocence, but in fact follows an old-established tradition of pictures designed to make the viewer think about the transience of earthly life (there's a broken pot at the child's feet, and his bubble, however beautiful, is soon going to burst). None of this mattered to Thomas Barratt, wealthy owner of the firm that made 'Pears' Soap'. He had seen a vision of how high art could be tethered to something that did matter a great deal, to him and other industrialists – making money.

Victorian Britain was the first consumer society. Printed advertising covered the streets of every city, far more densely

than today. Barratt, with a premium product aimed at the middle classes, saw that the right visual could cut through the monotone verbiage. For £2,000 (say, a quarter million today) he bought Millais' painting and the copyright. He then spent ten times that on putting his image – for it now belonged to him – everywhere.

Once it had been sold into the service of commerce, authenticity meant nothing. Barratt's advertising-men simply inserted the name of their brand, plus (with cunning *faux*-discretion: small and almost out-of-frame, yet unmissable) a bar of their soap. What Millais had originally intended was neither here nor there: the picture was now all about innocence and cleanliness – next to godliness, of course, in the pantheon of the Victorian middle classes – and their joint incorporation in a bar of Pears' soap.

At first, Millais rather enjoyed his art being plastered all over the country. After all, keeping up Millais' reputation was important to Barratt, and the industrialist made sure that he reproduced the un-retouched original in the *Pears Annual*. But soon, the elderly pre-Raphaelite found himself mocked for selling out the group's high ideals. In 1895, the well-known novelist Marie Corelli put these words into a character's mouth:

> I am one of those who think the fame of Millais as an artist was marred when he degraded himself to the level of painting the little green boy blowing bubbles of Pears' soap.

What was to become of 'high art' in the new age of infinite reproducibility, consumerism and middle-class morality? Would artists have to carefully disguise their depths, like Christina Rossetti, or allow their work to be modified at will by commerce, like Millais? Was everything to be reduced to a harmless, sexless fantasy-world of innocence and purity? The very year Corelli mocked Millais, one writer in London had the suicidal courage – or perhaps, the arrogance – to publicly challenge the comfortable myths of Victorian convention.

EXPLORE FURTHER | John Strange Williams and Sarah Ann Williams, painting (ca. 1830; Guildhall Art Gall.) • 'Ophelia' by John Everett Millais, painting (1851–2; Tate Britain) • *Peter Pan, or The Boy Who Wouldn't Grow Up* by J.M. Barrie, play (1904)

The Picture of Dorian Gray

Oscar Wilde | 1891

Wilde is constantly pushing back at 19th-century morals, to hold the mirror up to society and show the hypocrisies by which it functions.

RUTH LIVESEY

In *The Picture of Dorian Gray*, Oscar Wilde (1854–1900) delivered an unforgettable vision: the beautiful youth whose sins and leave him outwardly unmarked while a portrait of him – his soul – changes hideously.

The dream of appearing ever-young despite having embraced all the temptations of metropolitan life could hardly be more modern, and that's because the story is really about the most modern place on Earth: Victorian London, the world's biggest, richest and most hypocritical city, where the first telephone call was made and where William Gladstone, four times Prime Minister, stalked the night looking for 'fallen women' to 'save', afterwards whipping himself in punishment. As Wilde has Dorian put it:

I felt that this grey, monstrous London of ours, with its myriads

of people, its sordid sinners, and its splendid sins, must have something in store for me.

The story was born at a remarkable literary lunch. On 30 August 1889 at the Langham Hotel, Wilde and Arthur Conan Doyle were wined, dined and signed up by Joseph Stoddart, editor of *Lippincott's Monthly*. Conan Doyle delivered the second-ever story about his new character, Sherlock Holmes, in which we learn that Holmes injects cocaine because of his craving 'for mental exultation'; Wilde produced *Dorian Gray*, in which crime is 'simply a method of procuring extraordinary sensations'.

In all the adaptations, these two extreme late-Victorian thrill-seekers remain Londoners. You can't imagine them anywhere else. Yet both were created by outsiders: Wilde was a Dubliner, Doyle from Edinburgh, and Stoddart, who green-lit their commissions that afternoon, was (like his magazine) American. They were able to divine that Imperial HQ, its stultifying public morality headed up by 'the Widow at Windsor', was the perfect stage for stories about crimes, murders and secret desires.

Outraged reviewers saw that *Dorian Gray* described something unmentionable, indeed illegal if enacted: homosexual desire. They dared not say it openly: Wilde was married, with children, and the toast of London. As long as he stayed behind the firewall that said Art was not Life, he was safe. Then – like some modern celebrity needlessly engaging with a social media troll – he sued the Marquess of Queensberry for calling him a 'somdomite' [*sic*]. It was a fatal move because the sensational trials that ensued would now be about the man, not the artist. Rent-boys were induced to speak up, and Wilde was doomed.

Victorian morality had triumphed. Shattered by his two years in Reading Gaol, Wilde rotted away in France. There, he was visited by a young painter friend who hadn't spoken up in his defence, but who had crossed the Channel to hone the skills with which to confront the darkest corners of London.

EXPLORE FURTHER | *Salomé* by Oscar Wilde, play (1893) • *'Fantaisie en Folie'* by Robert Brough, painting (1897; Tate Britain) • Illustrations to *Salomé* by Aubrey Beardsley (1907; British Library)

Camden Town Nudes

Walter Sickert | 1905–13 | Various locations

Sickert is one of the greatest painters that ever lived He shone a light into the darkest spots, not just in terms of urban degradation, but also in terms of moral degradation. He wanted to show us what life was really like for other people.

GUS CASELY-HAYFORD

Walter Sickert's 'Camden Town' paintings resulted from years he spent being mentored in Paris by Edgar Degas, from whom he learned the idea of combining the new impressionist style with unconventional subject matter, such as the very non-respectable lives of poor urban people, especially poor women. Sickert was one of the first to cross back over the Channel with this new style, and the art critics of London were duly shocked.

But the artist only hit the headlines when he produced a painting called 'Jack the Ripper's Bedroom' (1907), claiming

he had slept in it himself. The following year, after another gruesome, Ripper-style murder of a prostitute, Sickert took several paintings that don't actually contain any violence, and that he had already shown under different titles (one with the deeply un-sensational name 'Summer Afternoon') and re-branded them 'The Camden Murders' for a new exhibition. It certainly got him attention – and being collected by Lord Beaverbrook ensured he made money too. But had he played the fame game too well for his own good?

> He did it deliberately, to bring his art to the public's attention ... seeing how the newspapers had gone crazy over the Camden Town murder, this clever, sneaky observer of human foibles saw a way to get his art noticed. Alas, the move backfired. Yes, the paintings were noticed. But their curse is to be associated for ever with a murderous mood that simply isn't there.
>
> WALDEMAR JANUSZCZAK

Murderous or not, Sickert's paintings, with their atmosphere of despair, their squalid settings and their putrid flesh-tones, suggest that there is something rotten at the heart of the Empire. The future was to prove him right. Britain was standing on the edge of an abyss. Despite fighting as one unit to win – or at least, to play a big role in winning – two vast World Wars, the greatest empire the world had ever seen was to disappear entirely within just 60 years.

It is hard to think of any nation which has fallen so far, so fast. Small wonder that Britons scarcely knew what had hit them. But as so often, great events called up great creations. Out of that traumatic collapse, brand-new art-forms would arise, and Britain would find a new voice in the world: not as its workshop, nor as its imperial master, but as a great factory of its dreams.

EXPLORE FURTHER | *Strange Case of Dr Jekyll and Mr Hyde* by R.L. Stevenson (1886) • 'The Doll's House' by W. Rothenstein, painting (1899–1900; Tate Britain) • 'Mrs Mounter at the Breakfast Table' by Harold Gilman, painting (1916–17; Tate Britain)

7. WARS AND PEACE

For many years Britons watched from the side-lines in 'glorious isolation' as France and Russia lined up ever more blatantly against Germany and Austria. Never in the history of human conflict has so great a power been granted so long to pick sides. By 1912, though, the die was cast and our military leaders were planning hand-in-glove with Paris, with the tacit permission of our elected leaders.

Since the point of the alliance with France was presumably to deter Germany, the sane move would have been to make our position public. After all, a deterrent only works if the other side knows about it. Instead, our military commitments to France were kept so secret that in July 1914, they were unknown to most of the Cabinet, never mind the Kaiser. This lunatic situation arose because we were locked in battle about who 'we' were.

The Liberals and the Conservatives were at each other's throats over the 'Irish Question', while a 'Home Rule for Scotland' bill also came before Parliament. The UK was imploding, and the embattled Liberal government simply dared not tell their voters (many of whom were pacifists) that they were planning for war with Germany.

So when war did indeed break out in August 1914, the national psyche (not to mention the army) was lamentably unprepared. As ever, it was creative minds that first realised things would never be the same.

Easter, 1916

W. B. Yeats | 1916

I have met them at close of day,
 coming with vivid faces
From counter or desk among grey
Eighteenth-century houses.
I have passed with a nod of the head
Or polite meaningless words,
Or have lingered awhile and said
Polite meaningless words,
And thought before I had done
Of a mocking tale or a gibe
To please a companion
Around the fire at the club,
Being certain that they and I
But lived where motley is worn:

All changed, changed utterly:
A terrible beauty is born.

'A terrible beauty is born' was a prophetic statement, and not just for Ireland. Yeats was able to read the *zeitgeist*.

KIERAN O'CONOR

The Easter Rising in Dublin 1916 really did change everything. Most Irish historians agree that before it, nationalists would have been content with what we might now call 'Devo Max' – a very high level of self-determination, but within a political framework spanning both islands. After it, the

die was cast: now nothing less than a full break with London would be enough.

Ever since, historians and commentators have been looking at the details of what the rebels actually wanted, how the ruthlessly heavy-handed reaction of the British played into the hands of the extremists, and so on. Yeats was neither a political commentator nor historian, but an artist of extraordinary sensitivity, and his poem registers what really mattered in April 1916. He realised that the Rising wasn't about a precisely articulated message, but about constructing a *terrible beauty*.

A century earlier, another poet, Keats, had announced his new aesthetic principle: 'Beauty is truth, truth beauty'. Yeats grasped that in Dublin in 1916, this had become a political reality: it was the 'beauty' of the Rising (though terrible) that made it 'true'. Irish politics had entered an era when rational debate was powerless compared to mythic spectacle.

Unfortunately, this turned out to be true not just of Ireland. Yeats had scented out the spine-chilling, awe-inspiring theatricals of Hitler's flood-lit Nuremberg Rallies and of Stalin's great parades in Red Square: vast, stage-managed spectacles in which visions of the alleged struggle and sacrifice of the glorious dead for an allegedly even more glorious future drowned out all doubt in the minds of the living. Politics was no longer to be about divisive, troublesome, rational discussion. It was now all about unifying visions of sacrifice: beautiful perhaps, but terrible indeed.

Yeats, from a restless land seeking a new future, understood in his bones the magnetic vision of hope through sacrifice (he later flirted briefly with Ireland's own Fascists, the Blueshirts). Across the Irish Sea, other artists rejected Britain's demand for glorious death in the name of the existing order, and tried instead to find havens of peace amidst the catastrophe.

EXPLORE FURTHER | 'Ode on a Grecian Urn' by John Keats, poem (1819) • *Dubliners* by James Joyce (1914) • 'Merry-Go-Round' by Mark Gertler, painting (1916; Tate Britain)

Charleston Farmhouse

Vanessa Bell et al. | 1916–20 | East Sussex

You could say the Bloomsbury Group were avant-garde artists trying to break away from the conformity of Edwardian England. You could also say they were spoilt, entitled, annoyingly pious and self-satisfied narcissists.

DOMINIC SANDBROOK

As we look at how Vanessa Bell, her second husband, Duncan Grant, and their friends decorated Charleston Farmhouse in the South Downs, we may not immediately understand why they – the Bloomsbury Group, those 'grand-masters of mediocrity', as the critic Philip Hensher has called them – should still be interesting.

Perhaps what compels people isn't so much what they created, but how they lived. They invented the idea of London artists going wild in the country, funded by someone or other's private income, having sex more or less indiscriminately, and exhibiting together under a vaguely radical umbrella, thus fascinating the middle classes and ensuring that galleries back

in London took note. This template was followed by the St Ives artists and is still found useful.

Yet there is something truly interesting about them. While Yeats's *terrible beauty* was dawning on the Continent – with real Modernist Art and real modern dictatorships – the Bloomsbury Group, while thinking of themselves as Modernists too, were – consciously or otherwise – grasping for something 'small-c' conservative. When Bell first described Charleston, she saw it not as a dynamic creative hub, but as an ancient, walled haven (the Somme was raging even as she wrote):

> Lovely, very solid & simple… a wall edging it all round the garden part, & a little lawn… a small orchard & the walled garden… There's a wall of trees – one single line of elms all round two sides which shelters us.

Twenty years earlier, the South Downs was where the new National Trust had bought its first property. Easy for the well-off to reach from London by motor-car, the area was by 1914 already the default setting for visions of Deep Southern England. Just after the war, the future BBC broadcaster S.B.P. Mais wrote in almost religious terms:

> Suddenly, out of the hidden lane, right across our bows came the South Down Hounds, home after cubbing… We were silent: we had all seen a holy thing: we had seen England.

It's easy to mock the idea of escaping Edwardian morality by creating a sexed-up, trust-funded re-jig of rural English life, handily located for London. But there's nothing funny about longing for shelter in age of mass slaughter.

After all, even a thoroughly non-radical painter grown rich and famous within Edwardian culture, an Irishman happy with a shared British identity, found that the war changed his work utterly.

EXPLORE FURTHER | *Jacob's Room* by Virginia Woolf, novel (1922) • 'Bertrand Russell' by Roger Fry, painting (ca. 1923; NPG) • 'Gloomsbury' by Sue Limb, BBC radio sitcom (2012–2018)

To the Unknown British Soldier in France

William Orpen | 1923 | Imperial War Museum

'To the Unknown British Soldier in France' is something of an anomaly, neither traditional nor avant-garde, but for a few years in the 1920s it was a site in which passionate debates about the war and its memory were played out.

AMY LIM

William Orpen was the most successful society painter in Edwardian London, glorifying his moneyed sitters in the grand old style, either individually or in the groups which were a particular speciality of his. He was already 36 in 1914, so he could have sat out the war without comment, famous and

wealthy. Instead, he used his social connections to badger the authorities until he was allowed to go to the Western Front as an official War Artist. It was normal for such artists to spend only three weeks in danger, but he stayed for far longer, and returned again and again.

Though his pictures were unflinching, they were approved by the authorities, partly because of his status. Indeed, in June 1918, when the British Army was desperately fighting with its 'backs to the wall' (as Haig's famous order put it) against Germany's last great offensive, he was made a Knight of the British Empire. After victory, he seemed the obvious choice to record the formal end of this 'war to end wars' when delegates gathered at the Palace in Versailles to sign the peace treaty. His fee for three paintings was £6000 – at least £500,000 in today's money.

But his years at the front had changed the way this superstar of the Edwardian artistic establishment saw the world. He delivered the first two pictures – 'A Peace Conference at the Quai d'Orsay' and 'The Signing of Peace in the Hall of Mirrors' – as expected, fully in-genre. But when it came to the third, 'To The Unknown British Soldier in France', something in Orpen seems to have snapped. Having spent months arranging the figures of mourning officers and dignitaries, he suddenly painted them all out, leaving only the flag-draped coffin guarded by two emaciated Tommies who seem to have come straight from some medieval Dance of Death. At the Royal Academy Summer Exhibition in 1923, it was a huge hit with the public, and became the subject of a culture war between conservative and liberal newspapers. The Imperial War Museum refused to accept (and pay for) it until he had painted out the deathly soldiers in 1928.

National morale, after all, had to be preserved. It had already been severely tested by the 1926 General Strike. Worse was to come as the Great Depression hit in 1929. The next year, it was hoped that a great new British liner, decorated by a galaxy of our finest artists, would be the required mood-enhancer.

EXPLORE FURTHER | 'Dulce et Decorum Est' by Wilfred Owen, poem (1917) • 'The Mad Woman of Douai' by William Orpen, painting (1918; IWM) • 'War Requiem' by Benjamin Britten, music (1961–2)

Queen Mary Ocean Liner

John Brown Shipyard | 1930–4

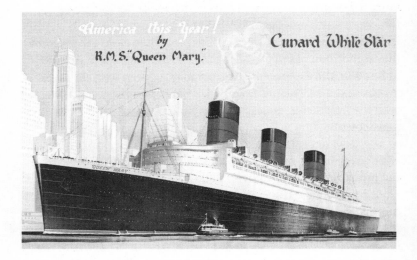

The Queen Mary is supported by government. It is, in effect, a Depression recovery project.

MURRAY PITTOCK

The RMS Queen Mary might have rusted away on the stocks after construction halted in 1931, the Great Depression having wiped out the luxury transatlantic passenger trade that she'd been planned for. When work resumed in 1934, it was only thanks to public funding – which was only awarded because people were beginning to notice a fatal flaw within our economy.

In the late 19th century, British financial elites began redirecting the wealth amassed from Empire and Industrial Revolution. The stock exchanges of New York and London had become a single 'information zone' for investors, and returns were higher in the fast-growing economies of the New World than in the already-developed UK. So the City followed the money: no country has ever invested so great a proportion of its national wealth abroad as Britain did in the decades before 1914.

The 'Workshop of the World' was turning into the investment banker of the developing world.

This supported more and more financial service jobs in Greater London – the sort of jobs which recovered fastest as the international economy picked up – but starved the UK of industrial investment. After 1925, when Churchill drove through the re-adoption of the Gold Standard in the interests of the City of London, the gap became impossible to ignore. The Ministry of Works in the 1930s officially divided the UK into two 'sections', with the 'Northern Section' meaning the North of England, Wales and Scotland.

The 1934 decision to complete the Queen Mary on the Clyde, with government support, was meant to restore morale to the industrial UK (without actually spending much or doing anything radical). Huge amounts of publicity were concentrated on this one ship, as though she could single-handedly restore the glory days. Rather as they had been under Charles I's ramshackle and bankrupt regime, artists were mobilised *en masse* to glorify a social and political fantasy. Thirty of Britain's most prominent creators were commissioned to work on murals, hangings, textiles, carpets and lighting.

> The decor involves a bit of Art Deco, lots of swirls, and a combination of cosmopolitan modernity with all sorts of reminders of sitting in a large English country house.
>
> PATRICK WRIGHT

The Queen Mary was, in short, design-led to send a typically British message: her blend of Modernism and tradition proclaimed that while we were a cutting-edge, go-ahead nation, the old ways were being upheld. That idea was pushed further the following year, when the scion of an ancient aristocratic family enabled a foreign architect to bring full-on European Modernism to these islands for the first time.

EXPLORE FURTHER | Brangwyn Hall (1934; Swansea) • Eltham Palace (1930s; Greenwich, London) • Philharmonic Hall, Liverpool (1939)

De La Warr Pavilion, Bexhill

Erich Mendelsohn & Serge Chermayeff | 1933–5

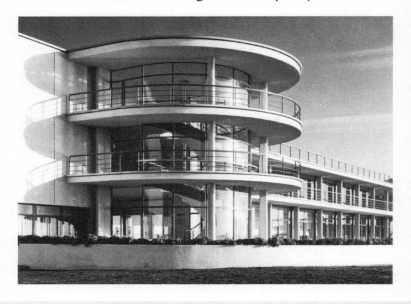

It took émigrés to bring this style to Britain. But then they were able to do something very English. It's a German modernist building that can be side by side with a Punch-and-Judy show.

LARA FEIGEL

The Bexley Hill Pavilion (1935) introduced to these islands a modernist architecture that was the literally concrete expression of fashionable thought among both the radical Left and the radical Right in Europe. In place of the chaos of War, Revolution and Depression, the future was to be about rational organisation and efficiency. Whether you believed this should be directed by a racial elite or a political-intellectual elite made little practical difference to the kind of buildings you proposed. The model for architecture was to be the factory, in which a new kind of humanity would be produced.

The British version of this utopian dream was a typical blend

of reformist thinking and conservatism. It was the pet project of Herbrand Edward Dundonald Brassey Sackville, 9th Earl de la Warr and Mayor of Bexley Hill, one of the southern towns leading the way out of the Great Depression. The Earl was a senior member of the tiny National Labour movement which backed the National Government (overwhelmingly composed of Conservatives): he believed in a paternal socialism which would deliver modest, curative doses of the New Jerusalem from the top down, avoiding dangerous radicalism of any sort, whether proposed by Sir Oswald Mosley or the Labour Party. To this end, he initiated the competition for a stand-out new cultural centre which would help to revive and make fashionable Bexley Hill.

Art being as ever ahead of the curve, the idea of an imported, Modernist utopia in concrete and steel, delivered thanks to an aristocratic commission, had already been mocked before it happened, in Evelyn Waugh's breakthrough satire, *Decline and Fall* (1928):

> It was Otto Friedrich Silenus's first important commission. 'Something clean and square', had been Mrs Beste-Chetwynde's instructions...
>
> 'The problem of architecture as I see it,' he told a journalist who had come to report on the progress of his surprising creation of ferro-concrete and aluminium, 'is the problem of all art – the elimination of the human element from the consideration of form. The only perfect building must be the factory, because that is built to house machines, not men.'

The Earl de la Warr awarded the contract to Erich Mendelsohn (a refugee from Nazi Germany) and Serge Chermayeff (whose family had lost everything in the Russian Revolution). European Modernism had landed, and the press spoke of a 'People's Palace'.

Meanwhile, however, in the still-depressed north, people were less interested in palaces, than in jobs.

EXPLORE FURTHER | Silver End Village (1926; Braintree, Essex) • Penarth Pier Pavilion (ca. 1926; Penarth, Cardiff) • 2 Willow Road, des. by Ernö Goldfinger (1939; Hampstead, London)

Coal-Searcher Going Home to Jarrow

Bill Brandt | 1937

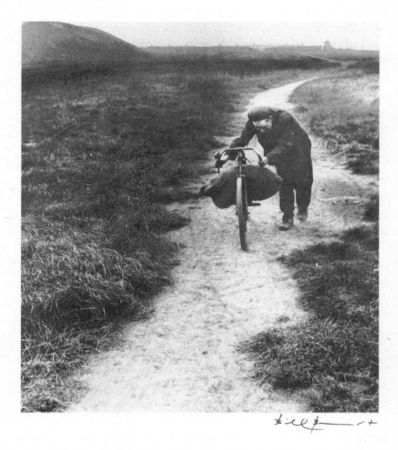

Of course it goes without saying that it's a beautifully graduated image. He goes all the way from the misty distance through to the stark blackness of the figure himself.

IAN CHRISTIE

Bill Brandt's famous photograph appears at first sight to be completely, grittily authentic. As indeed it was supposed to.

But look at the composition: the path carries the eye from the bottom left corner to the right top corner, with the focal point of the image, the figure travelling wearily towards us, placed exactly where the 'golden ratio' says it should be. Any 18th-century landscape artist would have understood those principles.

In the early 1930s, Brandt was an apprentice in the Paris studio of Man Ray, the great experimental photographer, where he learned to treat the shot taken by the camera as just the starting point for the process by which the final picture, the artist's own vision, was created. But there was another new school of pho-tography on the block. Brassaï's game-changing 'Paris by Night' (1933) embraced the latest camera technology, combining porta-bility, quick-winding, fast shutter-speeds and compact, powerful lenses. For the first time, it was possible to capture studio-quality images from un-staged life. Brandt united both schools, offering images which had the aesthetic satisfaction of artistic composi-tion, yet still appeared to come straight from the real world.

In 1937, Britain was ready for 'A Coal Searcher Going Home to Jarrow'. The North-South divide was already the great national talking-point. J.B. Priestley had written about it in his *English Journey* (1934); Orwell was about to publish *The Road to Wigan Pier*; Jarrow itself had shot to national fame when 200 men marched from there to Parliament in October 1936. In cinemas everywhere, Britons saw the openly sympathetic British Pathé newsreel. All that was needed was a single unforgettable image to sum it all up. Brandt duly went up north and obliged, with his irresistible combination of authenticity and art.

For all the interest, it took war to heal the divide (and then only briefly). With Hitler poised to strike in 1940–1, northern industry not southern financial services stood between us and defeat. By mid-1942, survival was assured and, in the teeth of personal opposition from Churchill, Britain's most successful movie-makers began work on a film that asked the next great question: were we fighting to hold onto the past, or for a new future?

EXPLORE FURTHER | 'A Night in London' by Bill Brandt, photos. (1938) • 'Untitled (Pithead Scene) by Nicholas Evans, painting (1976; Glynn Vivian Art Gallery, Swansea) • 'In Flagrante' by Chris Killip, photos. (1973–85)

The Life and Death of Colonel Blimp

Powell and Pressburger | 1943

There's some wonderful correspondence in which Churchill writes a memo to his Minister of Information, saying, 'Pray propose the measures necessary to suppress this film,' and Bracken says, 'We can't, Sir. It's a democracy'.

IAN CHRISTIE

The film, named after a then-famous cartoon character by David Low, opens in the present day, 1943. A war-game between the Army and the Home Guard is due to start at midnight. But a jolly group of junior officers decide to do it 'like Pearl Harbor'. They assemble a crack squad of 'toughs' (whose surnames or nicknames carefully tick all the boxes of the multi-national, multi-regional UK) and capture Major-General Candy of the Home Guard while he is still relaxing in a Turkish bath.

Faced with his comical outrage at this breach of protocol, the young lieutenant makes his killer point: 'We… keep to the rules of the game, and they keep on kicking us in the pants.'

Yet this is no simple plea for more ruthless efficiency in the conduct of the war. General Candy may at first appear to be a mere comic character, but it's a sucker-punch: the film now flashes back to tell the whole story of his bold, honourable, even romantic life. We learn that he truly was a splendid fellow. And back in the present, he sees the funny side of his capture and invites the lieutenant, symbol of the new generation, to dinner. We fade out to 'The British Grenadiers'.

Audiences loved it. Writer and producer, Emeric Pressburger, a Hungarian-Jewish exile from Nazi persecution, had created a loving and hopeful picture of a land in which the past and the future were united. So why did Churchill so hate it?

It's a classic case of true artists, consciously or not, being seismographs of social change. By 1943, US manpower and machinery were flooding into the country, while the Russians were holding, and even defeating, the Nazi war machine. No longer seriously fearing invasion or defeat, Britons had their eyes on a post-war future. Industrial strikes became commonplace again. Published at the end of 1942, the Beveridge Report, foundation document of the Welfare State, was by late 1943 (uniquely, for a government White Paper) a national bestseller.

Small wonder Churchill was unnerved by a film which, though it treated the elderly, class-bound social-military elite – men like him! – with affection, clearly said that it was time for them to make way. The British people might be ready for more sacrifice, but they weren't fighting 'a gentlemen's war' to preserve the existing order.

But what if even victory wasn't enough? In April 1945, with the war all but won, visitors to one of London's great galleries were shocked to see how completely one artist believed everything had changed.

EXPLORE FURTHER | 'The 49th Parallel' by Powell and Pressburger, film (1941) • 'In Which We Serve' dir. Noel Coward and David Lean, film (1942) • 'Oh! What a Lovely War!' dir. Richard Attenborough, film (1969)

Three Studies for Figures at the Base of a Crucifixion

Francis Bacon | 1944 | Tate Britain

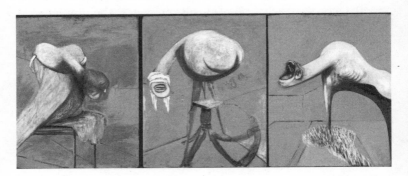

Many described the horror of seeing the painting, these figures at that time, in 1945 – and one critic even described how he couldn't stay in the room. He had to leave because he found them so disturbing.

MARI GRIFFITH

British art finally had a painter who wasn't going to seek any kind of safe haven. Bacon, hitherto completely unknown, but suddenly exhibiting alongside Graham Sutherland and Henry Moore, followed work like Picasso's 'Guernica' to its logical conclusion, questioning whether, in an age of such tortured flesh, anyone could believe in a human soul. Was there really any difference between man and beast?

Visitors to the Lefevre Gallery in April 1945 had only recently seen newsreels of the Nazi death-camps, so images of death and atrocity were nothing new to them. Some, indeed, would have experienced such things during the Blitz, or in battle. What was new, and truly shocking, was art that didn't even attempt to find any kind of consolation in the trauma.

There's no doubt that Bacon meant what he painted. There is

also no doubt that he hit the jackpot: the man responsible for his big break, Sutherland, was the perfect mentor in the brave new era of state-funded art.

During the war, the Council for the Encouragement of Music and the Arts, under the Earl de la Warr (he of the Bexley Hill Pavilion) had extended government sponsorship of the arts to an unprecedented level. An official pamphlet explained:

> No tendency to vulgarize the arts in order to achieve quick popularity has been permitted. Instead the Council has worked with extraordinary success to raise the general standard of artistic appreciation. In 1939 an Artists' Advisory Committee, under the auspices of the Ministry of Information, was formed to commission suitable artists.

The CEMA became the Arts Council in 1946 under John Maynard Keynes. Henceforth, what really mattered to artists was whether quasi-state institutions like it, the Tate or the BBC backed them. And those places were run by people like Keynes, many of them personal friends of the incurably snobbish Bloomsbury Group. To them, baffling or outraging vulgar people was the first sign that an artist might be significant. Funding to 'raise the general standard of artistic appreciation' in the public ended up being directed by a network of posh aesthetic gatekeepers to people they considered suitable.

Sutherland was the perfect fit: well-connected in the old way, he was also a full-time government employee of the 'War Artists' Advisory Commission'. Just the man to make a young artist's career in 1945. This doesn't mean Bacon wasn't a great artist. It means the way to become 'a great artist' had changed and that Bacon benefitted mightily from the new dispensation.

The first great statement of that new dispensation was the Festival of Britain in 1951, which made the career of our next artist.

EXPLORE FURTHER | Wartime drawings by Henry Moore (1940s; Tate) • 'Holocaust/Resurrection portfolio' by E. Greenwood, paintings (1943; Ben Uri Coll.) • 'Christ in Glory in the Tetramorph' by G. Sutherland, tapestry (1962; Coventry Cathedral)

Contrapuntal Forms

Barbara Hepworth | 1951 | Harlow

'Contrapuntal Forms' was so significant for her. It just set the Barbara Hepworth trajectory shooting off.

RYAN GANDER

Hepworth's 'Contrapuntal Forms' was the most prominent open-air work at the Festival of Britain (1951). Her trademark surfaces, smooth yet weirdly pierced, seem to hint at unspoken emotional voids. From certain angles the sort-of-humanoids appear to be touching (they aren't); from others, it seems that the curves on one might match the gaps in the other (they don't). The whole, along with the title, suggests timeless figures yearning for true contact, yet unable ever to reach it.

It made Hepworth famous overnight. She'd been working for years, and after a visit to Picasso in 1933 had become the first British sculptor to embrace pure abstraction. But she'd never broken through (on one occasion Henry Moore, supposedly her friend and mentor, secretly dissuaded the Tate from showing her work). She might have continued to pursue her obsessive, curving, polished-and-pierced forms in authentic obscurity, had not the new postwar curatocracy embraced her. And so, in 1951, she was catapulted into an art world which was in one of its strangest ever periods. For, though nobody knew it at the time, the golden age of abstract art was backed by not only by London's ex-Bloomsbury gurus – but also by the CIA.

Abstract art was tied to the notion of the unfettered Creative Genius (e.g. Picasso). This made it the polar opposite of the Soviet Realist style backed by the Kremlin. So although President Truman, for one, despised such art, it was sponsored as part of the Cold War: the idea was to show the world that the same Freedom which gave Coca-Cola and washing-machines to ordinary folk, allowed individuals of genius to create whatever they wanted. In 1959, when the Tate found it couldn't afford a planned exhibition of abstract American art, the CIA conjured the money up overnight via a helpful foundation. Throughout the 1950s, Hepworth (like Bacon) enjoyed powerful support from the career-making art guru of the day, David Sylvester. He frequently wrote for the highbrow London magazine *Encounter* – which (though he didn't know it) was funded by the Committee for Creative Freedom, the CIA's culture-war arm.

Nobody can doubt Hepworth's obsessive dedication to her art. Her trajectory, though, reminds us that becoming enshrined as a 'great artist' always involves being in the right place at the right time, and often has more to do with unseen forces of politics and power than anyone at the time realises.

And by now, entirely new forces were coming into play: the Empire was coming home.

EXPLORE FURTHER | 'Mother and Child' by Barbara Hepworth, sculpture (1934; The Hepworth Wakefield) • 'Festival of Britain Mural' by Ben Nicholson (1951; Tate Britain) • 'Reclining Figure' by Henry Moore, sculpture (1951; Tate Britain)

Crucifixion

F. N. Souza | 1959 | Tate

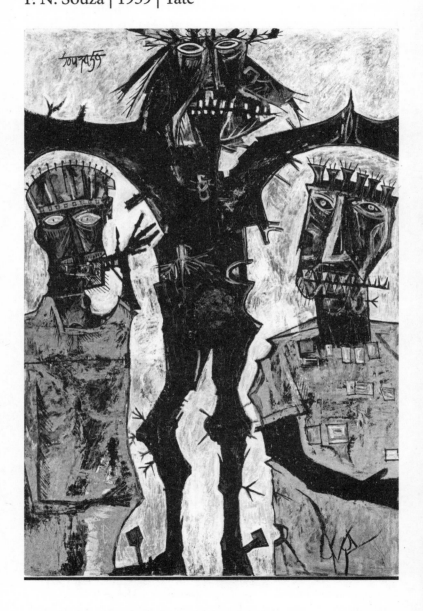

It's Souza saying, *I'm an artist from the Western tradition. I'm not an outsider*.

CONOR MACKLIN

A black Christ, his face like an African mask, bat-wing arms enfolding the mysterious figures beside him, bares his large and numerous teeth as he stares at us. There's no cross: He seems to stand, barely nailed down, as if about to step free. Is it Christ the Holy Terror coming for us, our central 'western' image re-imagined by a vengeful, colonial eye?

Or is it about the artist? In 1955, Souza had burst onto the London scene, where his work was labelled as *Art Brut* ('Rough Art'), a trendy term for creations by supposedly unschooled outsiders with challenging personalities. In fact, he was steeped in the Western visual tradition. After a Goan childhood surrounded by the imagery of Portuguese Catholicism, he studied at India's top art-school, the 'Sir JJ', founded in 1857 and almost entirely run by British teachers. Thrown out in 1945 for backing the anti-British movement, he was horrified by the inter-communal savagery of partition in 1947, and founded the Progressive Artists Group in Bombay. They rejected nationalist demands for artists to embrace traditional Hindu forms, arguing that artists in the new India should instead embrace international trends. Following complaints and threats, Souza in 1949 left for London. There, he succeeded – by being pigeon-holed as exotically 'rough'.

So did being free in Britain mean being free to be what others expected you to be? This wasn't just a question for the ex-colonial peoples now coming in numbers to the 'Mother-land'. Most white Britons were themselves still excluded – by class, education or accent – from truly partaking of the grand cultural 'us'. But the times they were a-changing. And not a moment too soon.

EXPLORE FURTHER | 'Crucifixion of the Soul' by Madge Gill, painting/drawing (1936; Newham Archives) • *The Mimic Men* by V.S. Naipaul (1967) • 'Two Little Blue Houses' by Pearl Alcock, drawing (1986; Whitworth Art Gallery)

8. BRILLIANT
ISLES

A Taste of Honey

Going, Going

Notting Hill Couple

The Buddha of Suburbia

Trainspotting

Peace Walls, Belfast

Everyone I Have Ever Slept With

Harry Potter and the Philosopher's Stone

The Passion of Port Talbot

Stormzy/Banksy at Glastonbury

Map of Nowhere

In 1939–42, the UK and the Empire had saved the world, and people understandably listened to the echo of those glory days for as long as they could. But deluding ourselves that we were still the country we had been in 1939 was crippling us. Throughout the 1950s, we were spending close to 10% of GDP on defence. In financial terms we were on a semi-war footing, because our leaders would not look the reality of decline in the face. The result was that we fell behind countries like Germany, (whose own delusions were buried safely beneath the rubble of Berlin) in education, transport and industrial modernisation. Yes, we had helped save the world in 1939–42, but we lost the peace in the 1950s.

No one wanted to see. Young men were still conscripted: for the vast majority of them, this meant hanging around pointlessly in bases, being schooled in the class system and the conscript's art of skiving while looking busy. Books, films, and even children's comics all repeated the same message: We Won the War and were still Great. The art establishment was locked into a post-Bloomsbury worship of abstract works which interested few outside a self-declared intellectual elite.

Yet if politicians and artistic bureaucrats thought nothing had really changed, creative minds were about to call time on this national delusion.

A Taste of Honey

Shelagh Delaney | 1958

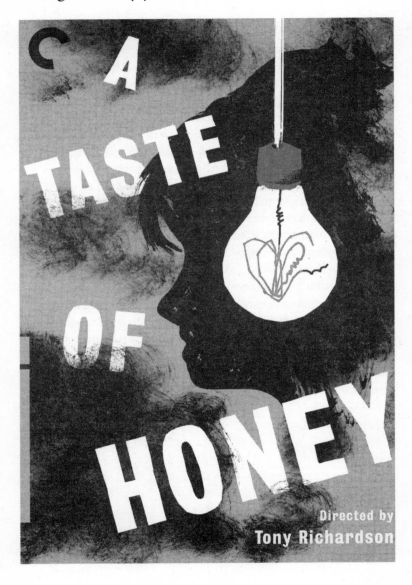

Gay culture, feminist culture, working class culture, black British culture... They're all there in *A Taste of Honey*, in 1958.

GRAEME MACDONALD

In 1958 a teenager from Salford threw a literary hand-grenade into the heart of the theatre establishment. Shelagh Delaney, a bus driver's daughter who had failed her 11-plus, stunned West End audiences by depicting the lives of ordinary Northerners as they'd never been shown before. The genre she helped pioneer would come to be known as the 'kitchen sink drama'.

Many of the play's issues are still live today. Take the scene where our heroine, Jo, gets a present from her friend Geoffrey, the almost-openly gay character who knows she is pregnant by a black man. His gift is a realistic, life-sized baby doll meant to suggest that he is ready to become a co-parent. But the doll is plastic-pink – what other colour could a baby doll be in 1958? – and Geoffrey's gift just brings home the almost unbearable racism Jo will soon face. With this nuanced approach to prejudice – not even a well-intentioned 'ally' gets the full picture – *A Taste of Honey* prefigured the debates about power and privilege that people are having today. The arts, as ever, were ahead of the game.

The play got its very own BBC documentary: in the dawning age of mass TV-viewing, the UK's cultural gatekeepers were open to radical new ideas. New sounds, too, for Delaney was offering a completely different kind of English to the 'RP' that dominated the airwaves, from working-class Manchester.

Yet with all change comes loss. Even as *A Taste of Honey* swept from the West End to Broadway, a very different English voice – a male one neither truly of the south nor of the north with which he is normally associated, educated in the manner of the elite yet not really of it – questioned whether the price of this brave new Britain wasn't too high.

EXPLORE FURTHER | 'Variation on a Theme' by Terrence Rattigan (1958) •
Sweetly Sings The Donkey by Shelagh Delaney (1963) • 'This Night Has Opened My Eyes' by The Smiths, single (1983)

Going, Going
Philip Larkin | 1972

There's this terrible pain in Larkin's writing and all this terrible yearning – and the yearning in 'Going, Going' is a sense of his own life ebbing away in tandem with this lyrical idea of England.

DAVID BADDIEL

In 1995, viewers of BBC TV's *Bookworm* voted three of Larkin's works into the *Nation's Top 100 Poems*. From the outside, his life as librarian at Hull University for 30 years seems almost a self-parody of our supposed national virtues: normality, modesty, a quiet, melancholy carrying-on in the face of change. Like so many of the creative spirits in our story, he seems obsessed with the need to defend a kind of secret continuity, declaring that he wrote poems 'to preserve things.' There seems little to argue with today in one of his most famous poems. Indeed, its ecological imagery seems positively prophetic:

I thought it would last my time...
Things are tougher than we are, just

As earth will always respond
However we mess it about;
Chuck filth in the sea, if you must:
The tides will be clean beyond.
– But what do I feel now? Doubt?
For the first time I feel somehow
That it isn't going to last...
And that will be England gone,
The shadows, the meadows, the lanes,
The guildhalls, the carved choirs.

But after his death in 1985, his private correspondence was opened, revealing that the man who was so loved by the UK's poetry-readers, and who'd been offered (but turned down) the job of Poet Laureate in 1984, was capable of merrily penning, and indeed preserving, private rhymes like this:

Prison for strikers
Bring back the cat.
*Kick out the n****rs*
How about that?

The original does not use asterisks. And in case anybody might think Larkin was just being ironic, one letter to a friend states plainly: 'Enoch was right, can't see why you call him a fool.'

Larkin's life and work open the whole Pandora's Box: should we stop liking the poems because of what we now know about the writer? Should the work of a poet who began publishing in the 1940s be rejected because of alcoholic ramblings from 30 years later? Or should we see Larkin, warts and all, as a salutary reminder that hair-raising ideas about race were still common in the second half of the 20th century? And that is precisely what made the work of our next artist so radical in its day.

EXPLORE FURTHER | The paintings of Eric Ravilious (1903–42) • *Collected Poems* by R.S. Thomas (1990) • Trellick Tower, archit. Ernö Goldfinger (1972)

Notting Hill Couple

Charlie Phillips | 1967

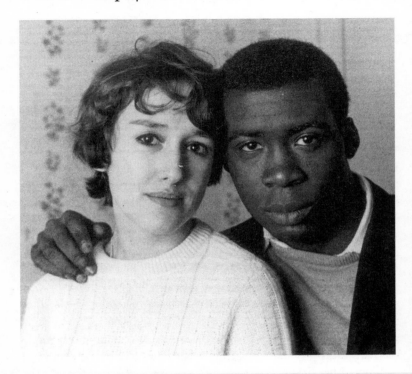

It's both a loving image, but also one that somehow manages to capture the fear and the hostility of that moment, that what they were doing was something audacious... It took a photographer like Charlie Phillips to humanise black people.

AFUA HIRSCH

If this young black man was not entirely at ease about being photographed with his young white lover, even by a black photographer, you can hardly blame him. That photographer, Charlie Phillips, arrived with his parents as part of the 'Windrush Generation,' who strongly identified as British. Many, indeed, had been in the forces during WW2. But when they got to the

'Mother Country', which urgently needed manpower to help postwar reconstruction, they found to their surprise that the native British didn't really believe in the Empire at all.

> For many West Indians... the shock was not the imperialism of the British but the lack of it. These British failed to recognise the West Indians as fellow, equal subjects of the Empire.
>
> DAVID EGERTON

Philip Larkin expressed his knee-jerk revulsion privately and secretly, at his desk, but others believed that phrases like 'kick out the n******' should be taken literally. In the Notting Hill riots of 1958, white youths came from far and wide to join in the assault. That started a national conversation about immigration, and the tone was by no means positive. Oswald Mosely finally bowed out of politics in 1966, but the following year, just two months after Charlie Phillips took this now famous picture, Enoch Powell stepped up to take the vacant place as Britain's leading posh racist. In his infamous 'Rivers of Blood' speech, Powell, who like Mosely was a paid-up member of the ruling class (he had been a star Classicist at Cambridge, then the youngest Brigadier in the Army), cried that he was breaking ranks with the elite, telling ordinary voters the dreadful truth, standing boldly against mysterious 'vested interests'.

Clearly, Facebook didn't invent conspiracy theories about 'the Establishment'. We were already entering the 'post-truth' age, and the messages conveyed by creative people became increasingly central to politics.

The contribution of Charlie Phillips was vital because the great social question of these years was whether white Britons would accept black Britons as part of yet another new us. In 1990, one child of a mixed-race marriage created a world-beating story which gave a message of hope – yet also worried that the chance has been missed.

EXPLORE FURTHER | 'To Sir with Love', film (1967) • *Poor Cow* by Nell Dunn (1967) • *Sergeant Pepper's Lonely Heart Club Band* by The Beatles, album (1967)

The Buddha of Suburbia

Hanif Kureishi | 1990

What a first novel! And what an opening line. It's one of the most iconic opening lines in contemporary British fiction, an immediate declaration of identity, and of solidity, and intent.

GRAEME MACDONALD

Hanif Kureishi's breakthrough was with 'My Beautiful Launderette' (1985), which won him the Oscar for Best Original Screenplay. Hollywood was languishing creatively in the mid-1980s, and after the success of Colin Welland's 'Chariots of Fire' four years earlier, it began to seem to American producers that British artists had something fresh to offer. Kureishi's bold, bright, tale of racial and sexual tension thus helped kick-start the modern love-story between Hollywood's matchless dream-making genius and Britain's unique creative take on the world.

Five years later came his debut novel, both family comedy and social satire, quizzing the state of the nation as well as his own cultural heritage and sexuality. Its opening line, with its beautifully judged sting in the tail, is unforgettable:

> My name is Karim Amir, and I am an Englishman born and bred, almost.

We are taken headlong from the joyless suburbs of south London into the heart of the city in the late 1970s. The location is so thrilling precisely because old values, both figurative and literal, are in free-fall. These were the years when the metropolis reached its lowest modern population, when (incredible as it may now seem) property prices were falling year on year; when entire streets of central east London were practically derelict; when whole blocks in the heart of the West End were squatted by left-wing alternative groups. This gave Kureishi's tale its dizzying sense of limitless possibility.

Like many great novels which seem to spring almost automatically from their age (Joyce's *Ulysses*, for example), *The Buddha of Suburbia* is a work of long-brewed creation. By the time Kureishi wrote it – certainly by the time the BBC adaptation broadcast this British Asian experience to millions in 1993 – London had been transformed. It was now the brash, booming city of the Yuppies and the Big Bang, beginning to detach itself from the rest of the UK, its incredible property prices already the talk of the press. Re-reading the book now, we can see that the in-your-face narration is secretly underpinned by an awareness that for all its vitality, this is really a story of youth and hope from a time now past. Nothing could be more Romantic, and such things never age.

Kureishi's heady tale of a young man trying to escape from the past and invent a new identity resonated across the nations of the UK – most powerfully, perhaps, in Scotland.

EXPLORE FURTHER | 'London Kills Me', film, Hanif Kureishi (1991) • 'Untitled' by Anish Kapoor, sculpture (1991) • *Fever Pitch* by Nick Hornby (1992)

Trainspotting

Irvine Welsh | 1993

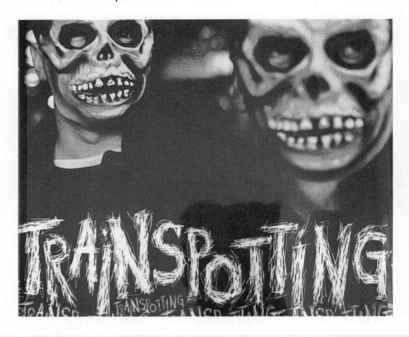

Ah've never felt British, because ah'm not. It's ugly and artificial. Ah've never really felt Scottish either, though... Ah don't hate the English. They're just wankers.

RENTON IN *TRAINSPOTTING*

Trainspotting shows just why creative artists should be listened to by anyone who wants to know what is coming next. For while Irvine Welsh was writing and publishing it, the Scottish National Party seemed firmly stuck on a mere handful of MPs. Barely 20 years later, it was dominant in Scotland (and loudly backed by the novelist himself). Commentators of the future will surely connect the renaissance of a self-consciously bold and different Scottish writing in the 1990s, headlined by *Trainspotting*, and this extraordinary political sea-change.

Like Amir in *The Buddha of Suburbia*, Renton in *Trainspotting* refuses to be told he belongs to anything – but he takes this to a new level. For unlike Kureishi, Welsh wasn't looking back to a time of youthful opportunity, but writing straight into an age that seemed to be going nowhere. The Conservatives' record fourth term made the UK feel like a one-party state. Never a good thing, this felt really bad in Scotland, which had voted massively against them. Everything seemed to be sliding: sterling plummeted and unemployment hit over 10%. In the new clubs, people dancing on ecstasy were spotted with *Trainspotting* sticking out of their pockets as a badge of their anti-identity.

> Choose life. Choose mortgage payments; choose washing machines; choose cars; choose sitting oan a fuckin couch watching mind-numbing and spirit-crushing game shows, stuffing fuckin junk food intae yir mooth; choose rotting away, pishing and shiteing yersel in a home… Choose life.

If we look beyond the swearing, we see that this famous passage is a positively classical rhetorical construction. For Welsh is far more educated than most of his early readers imagined, and his masterpiece was very cleverly made. When, at the end, Renton escaped for a new life by betraying his crew, it felt like the right, the only possible, ending – because it had been lying in wait throughout. Using a storytelling trick as old as the *Odyssey*, Welsh created a Hero who could revel in leading us through a depraved and deadly world because he was secretly confident that he alone was cunning enough to make it out alive, and tell his tale.

But if Scotland in the early 1990s was a place where the only identity which seemed to have any meaning at all was a purely individual one – rob your friends and get the hell out of it, why not? – its closest cultural relation on these islands was a very different place indeed. In Ulster, the idea of communal identity wasn't just alive, it had the place in a death-lock.

EXPLORE FURTHER | *Confessions of an English Opium Eater* by Thomas De Quincey (1821) • 'Twin Town', film (1997) • 'Mile End' by Pulp, song (1995)

Peace Walls

Various Artists | 1970– | Belfast

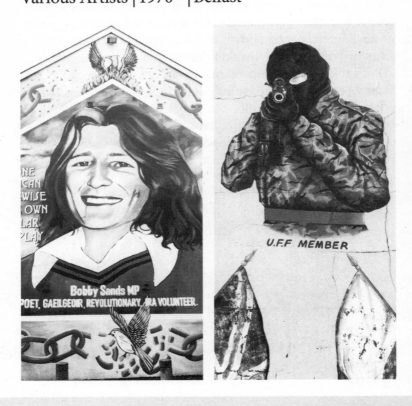

They're deeply problematic and they're intimidating and they're frightening objects. These are not scars, they're open wounds.

HEATHER JONES

Obsessively dwelling on dead men and badges of identity, these images line the barriers put up to minimise sectarian violence between communities. Up to six metres high, the walls extend over 21 miles in Belfast – and the murals on them rip away academic or aesthetic debate, reminding us that art has always been entwined with politics and power. It's just that here, the disguise is very thin indeed.

Basic things like perspective seem to matter little. Some of the Nationalist pictures are more sophisticated, being at times clearly descended from the images of saints and martyrs known to every Catholic schoolchild, but it's only a question of degree. And it's no coincidence that the images often look pre-modern: they are. This is art at Ground Zero, in a corner of the UK where the fake news atrocity woodcuts of 'The Teares of Ireland' (see p.70) are still used to justify lawlessness.

But it isn't 'folk art'. All political or religious imagery here has to be approved by the paramilitaries, who use art as Richard II (see p.30) used art: to glorify power. For all the symbols, at its core lies a simple message: the armed men and their death-cults are watching.

'The opportunity is there to take control of our identity and take it into the 21st century.' EMIC, BELFAST ARTIST

Since the 1998 Good Friday Agreement, more complex, less nakedly political images have begun to appear on the Walls, reflecting the desire of most ordinary people to move on. It helped that in 'Cool Britannia' identity had become super-soft-centred. What did the Union Jack mean if the Spice Girls could adopt it? Anyone could be whatever they wanted.

And one artist became famous, or notorious, overnight when she took individualism to a whole new level: her work wasn't just openly about herself but was – at first glance – about absolutely nothing else.

EXPLORE FURTHER | *Troubles* by J.G. Farrell (1970) • *North* by Seamus Heaney, poetry (1975;) • 'EU Mural' by Banksy (2017; online, or – painted over – in Dover)

Everyone I Have Ever Slept With
Tracey Emin | 1995

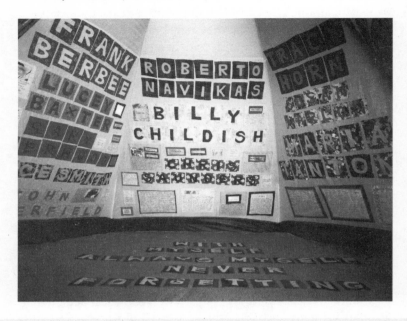

There was a particular kind of raw intensity and directness, an incredibly bold and shocking quality to the way that she did it.

HETTIE JUDAH

Tracey Emin in the mid 1990s was able to divine the way the world was going far better than any social historian or leader-writer, simply by laying aside her long training in her crafts (she had a first-class degree in printmaking as well as an MA in painting), taking a deep breath, and free-diving into the unlit depths of her own psyche. Her breakthrough work was, we can now see, nothing less than a prophecy.

In 1997, when her tent was first exhibited, selfies, ghosting, trolling, revenge porn and emotive blogging did not exist even in the heads of cutting-edge thinkers. In the Soho members' clubs where Emin and the other Britpack artists of *Cool*

Britannia drank, you could blithely cut your lines of coke in open view since neither phones with cameras nor social media had yet come into being.

So people were shocked when Emin purchased a cheap tent, embroidered it with the names of everybody she had ever slept with – sexually or not, willingly or not – and placed the words 'With myself, always myself, never forgetting' centre-stage. The notion that this was something worth looking at and thinking about – Art, in other words – seemed so surprising, not to mention so arrogant and self-obsessed, that it made Emin famous.

The technology that would make the obsessive display of our most personal selves into a gigantic mass market had not been invented. By doing in a gallery what hundreds of millions of people would soon be doing online, Emin was prophetically asking a great cultural question of our own age: when does the Fortress of the Self become the Tower of the Ego? And in choosing a cheap tent as the symbol of her self-hood, she was being prophetic in another way.

The United Kingdom in 1997 seemed more at ease with itself than for decades. Tony Blair's approval ratings after his 'People's Princess' speech on the death of Diana reached an impossible 93%. Ulster was at peace; the Welsh and Scots nationalists seemed happy with the new powers granted by their devolved assemblies; Blair played the middleman between Europe and America in a way that Churchill had only dreamed of. Everything, it seemed, was moving in the right direction. Yet 'Cool Britannia' soon turned out to be not a stable dwelling-place, but a tottering, flimsy, construct.

Emin was not alone in her creative intimation of just how fragile a shelter her nation really was. Another woman had just published the first volume of a saga that would make her the bestselling British author of all time. It told of a war to save an ancient institution, the orphaned hero's only home.

EXPLORE FURTHER | 'The Physical Impossibility of Death in the Mind of Someone Living' by Damien Hirst (1991; touring) • 'My Bed' by Tracey Emin (1998; Tate) • 'Frank' by Amy Winehouse, album (2003)

The Harry Potter Books

J.K. Rowling | 1997–2007

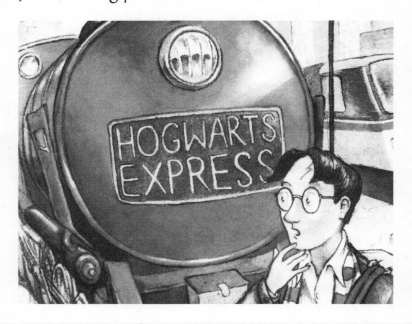

> There's still a class system operating – still a world of power –
> and it's in the bricks of Hogwarts, I think.
>
> GRAEME MACDONALD

A hero brought up without his real parents, summoned away
to discover his secret powers and save the world? It's one
of the oldest stories there is. So why did Harry Potter run riot in
the mental worlds of an entire generation?

It's the way you tell them, of course, and Rowling cleverly
structured her tale as a detective story. But her real alchemy was
simple conviction. Readers instinctively knew that the author
truly, madly, deeply yearned for Hogwarts to be real. Like the
troubled girl from Margate, Tracey Emin, this highly-educated
but poor and unemployed single mother in Edinburgh built her
very own place of refuge. You can't fake that authenticity.

But it's also about *when* you tell them. In Rowling's world, the Bad Guys say that to be magic you must be born into a hereditary caste, and that's the end of it. The Good Guys argue that magical traditions are not mere custom, but stand for actual values, so Hogwarts should always let in talented new people (so long as they respect its time-honoured ways, obviously). Neither side wants to abolish the basic distinction between Muggles and magical folk: the civil war is between hard-line conservatives and progressive conservatives.

The only major character born a pure Muggle is super-bright, super-keen-to-assimilate Hermione Granger, who marries into the magical elite and sends her children to Hogwarts. It's no coincidence that the design team for the films went so full-on for a Victorian Gothic look: Harry Potter is a deep celebration of the liberal conservatism that had seen Britain through wars and revolutions. And the Hogwarts Express steamed up to toot its message that *old stuff is basically good* smack on time.

For the UK was now ruled, for the first time since 1966, by a Prime Minister who both believed in Gradual Progress and had an unassailable majority. Tony Blair intoned *education, education, education* and the newly-rich middle classes agreed. There was a surge in the numbers of parents wanting to send their children away to get a 'traditional' (i.e. a Victorian/ Edwardian-themed) education. Some thought J.K. Rowling had personally saved the English boarding school.

Her saga of the desperate defence of an ancient institution now seems prophetic. For even as the 2010 government (now quite literally a Conservative-Liberal coalition) prepared to open the 2012 Olympics with a carefully-constructed display of our alleged national story, real Art was, as ever, sniffing out the truth. In one Welsh town, one of the strangest pieces of theatre ever staged – simultaneously mourning and celebrating a community laid waste by globalisation – got completely, wonderfully out of hand.

EXPLORE FURTHER | *Tom Brown's School Days* by Thomas Hughes (1857) • *The Chronicles of Narnia* by C.S. Lewis (1950–56) • 'England, Half-English' by Billy Bragg, album (2002)

The Passion of Port Talbot

National Theatre of Wales | 2011

What I hadn't realised was that everyone would get their phones out and start filming me. Thousands of people running at you with their phones! It was the very early days of all that kind of thing. That totally took me by surprise. Not for one moment had I thought that we were entering an era where everybody just films everything, just like that.

MICHAEL SHEEN

In 2011, over three days in Port Talbot, 25,000 people became both audience and participants in a retelling of the Passion of Christ. The participation was far larger than the producers had ever anticipated, and took completely unexpected forms.

In this new version, the ancient tale became an act of memory, a celebration of and a mourning for community life in a town that had been known locally as 'El Dorado' in the 1960s because of the new, well-paid jobs in the steelworks, but had fallen victim to the tides of globalisation. Michael Sheen's performance was unapologetically focused on this particular place. It offered what only live theatre can offer: powerful emotions delivered right in your face by real, living people. The people of Port Talbot responded – but few at the time realised that a new day had dawned in which everyone could be the star, director, producer, editor and broadcaster of their own video content, streamed around the world in seconds.

Commentators recognised that this wasn't just a landmark in the history of our theatre, but the harbinger of something new in our whole experience:

> People often made no distinction between the bits they saw live-streamed and the bits they saw played out... Many of those who weren't inside the Seaside Social and Labour Club as Sheen's character broke his sandwich in half and shared it with his followers, thought that they had been.
>
> LYNN BARBER

So do you have to be there, to be there, these days, when a single, live, unrepeatable act instantly becomes countless digital memories, each created by a different individual, from a different point of view? Can there ever again be a truly, commonly shared experience? What does Michael Sheen carrying a crucifix really mean, and to whom? And what did it really mean when Stormzy got up on stage in Glastonbury in 2019?

EXPLORE FURTHER | *How Green Was My Valley* by Richard Llewellyn (1939) • 'Night Shift, Port Talbot' by Gwyn Davies, painting (1950s; Nat. Mus. Wales, Dept. of Industry) • 'Everything Must Go' by Manic Street Preachers, album (1996)

Stormzy/Banksy at Glastonbury
2019

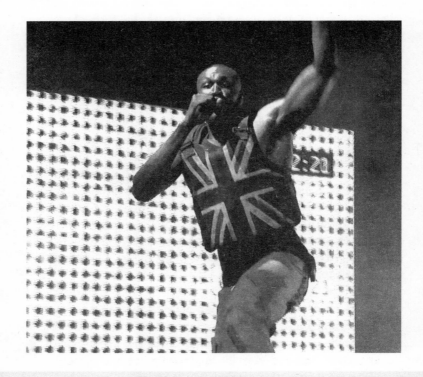

It's not Black British culture – it's British culture.

DEANA RODGER

Before that evening, politicians and the media routinely attacked Grime as something malignant and un-British. It celebrated ruthless ambition among young men; it encouraged gangs; it was yet another import from America.

Few mentioned that a longing for 'respect' from the other young men in your territory has been celebrated in art for as long as art has existed. To Homer, it was obvious that young men should desire 'kudos' above all things; the writer of *Beowulf* glowingly describes his hero as 'the most yearning for

renown'; the British Army prides itself on its ability to forge young men into groups of comrades loyal to each other unto death (gangs, in other words).

Another fact seldom acknowledged: Grime was born and bred in Britain. Of course, as with The Beatles, you can trace its roots to America, but, like The Beatles, it evolved into something new. Indeed, it has found life hard in America, partly because the vocabulary – so central to an art-form closer to performance poetry than singing – is hard for Americans to understand. As Stormzy put it: 'The Americans have their way of talking, their way of dressing, their way of doing things, and we have ours.' You can't help feeling that if this music had been *white* British, reactions would have been somewhat different.

Then came Glastonbury. Of all the things he could have worn, Stormzy chose a police-style stab-vest showing a torn and faded Union Jack, made (though he claimed not to know it) by the most popular British street-artist in history – Banksy. It's an image of genius, bursting with questions, yet resisting all easy answers.

We don't at first register that's it's black-and-white: the mind supplies the red and blue that aren't there. With its bleached look and leaching paint, it appears almost a relic in a post-apocalyptic world. Is it saying that the UK is history? Or something about the plague of stabbings among young black men? But then, it's an item a policeman would wear. And it is real, functional armour: that Union Jack is literally *protecting* Stormzy as he performs. It is his battle-flag and rallying point – a totem, perhaps not quite as we have known it, but still there, still somehow working. Our banner is his banner; he is one of us.

Is this a 21st-century version of Drake scorning the Armada or Churchill proclaiming Our Finest Hour, though the threats now are vaguer and the enemy less clear? We will weather every storm, the image seems to cry, even if it means creating ourselves anew. And even if all we have is a Map of Nowhere...

EXPLORE FURTHER | 'Anarchy in the UK' by the Sex Pistols, cover artwork (1976) • 'Irish Gothic' by Jock McFadyen, painting (1986–7; Wolverhampton Art Gallery) • 'Crown' by Stormzy, song (2019)

Map of Nowhere

Grayson Perry | 2008

Britain has always been a creative place – a place where waves of immigrants have come and reinvented themselves, brought their traditions, their world-views, and made them into something new. That has been the story for millennia.

AFUA HIRSCH

The Anglo-Saxon *Mappa Mundi* (p.16) told us nothing about how to get from somewhere to somewhere else, but a lot about the people who made it. Grayson Perry's modern version seems to be an attempt to work out what on earth we are today. Dead centre, the artist has placed what is surely our 'island fortress', with Elizabeth I sitting in Shakespeare's Globe Theatre. The word attached to this particular image is 'doubt'.

There is indeed no shortage of doubt right now, and of the most troubling kind: doubt about the story we tell ourselves, about ourselves. Is it a proud story, about a place whose language and laws now span the globe, and seem everywhere to go hand-in-hand with freedom and democracy? Or a story of extortion and oppression on a global scale? Or both? What next? Who will 'we' even be, in 20 years, 30 years, 40 years? Being human, we long for certainty.

Yet our story has never really been about certainty. Over the past 1,500 years, we have known massive dislocation and grand reconstruction, waves of migration and assimilation, ceaseless political demolitions and re-buildings. Again and again, we have faced mortal threats, from within and without. Somehow, each time we have come through – and come up with something new that yet preserves something good of the past.

If we want clues about what is waiting in the wings, at least we know where to look. Not at the social and economic maths, the ministerial statements, the policy documents, but at what is being done by those who even now are busily forging the next chapter in the grand story of our creativity. For it is the artists, in every age, who have always been the first to sense what's past, and passing, and to come.

EXPLORE FURTHER | *A Pilgrim's Progress* by John Bunyan (1678) • 'Imperial Federation Map of the World Showing the Extent of the British Empire in 1886' (1886; online) • 'A Map of Days' by Grayson Perry, etchings (2013; NPG)

Image Credits

Chapter One (pp 4-19)

p.4 Spong Man, Norwich Castle Museum. Commons, user: geni, November 2015

p.6 Artist and performer Sean Parry with a *byddar* drum © ClearStory/Menace Productions

p.8 An item from the Staffordshire Hoard, displayed in the Potteries Museum and Art Gallery, © ClearStory/Menace Productions

p.10 Aberlemno Stones, Angus, Scotland ca. AD 500-800 © ClearStory/Menace Productions

p.12 Incipit (introductory) page to the Gospel of St. Luke, Lindisfarne Gospels, ca. 720 AD. British Library; MS Cotton Nero D IV, online: http://www.bl.uk/manuscripts/FullDisplay.aspx?ref=cotton_ms_nero_d_iv) © ClearStory/Menace Productions

p.14 'Grendel's mother carries Beowulf to the bottom of the lake'. Illustration by Henry Justice Ford in *The Red Book of Animal Stories*, Andrew Lang, 1899. Public Domain: Commons

p.16 The Anglo-Saxon Mappa Mundi, 2nd quarter of 11th century. MS Cotton Tiberius B V/1, © The British Library Board. All Rights Reserved/Bridgeman Images

p.18 Details from scene 57 from the Bayeux Tapestry: 'Hic Harold Rex Interfectus Est' (Here King Harold is slain), 1070s. Commons, user: Myrabella, March 2013.

Chapter Two (pp 20-43)

p.22 Illustration by unknown artist, in 'Pearl', 14th century. MS Cotton Nero A X, art.3 f42r 007079. © The British Library Board. All Rights Reserved/Bridgeman Images

p.24 Knight on horseback, choir stall misericord carving, Lincoln Cathedral, c. 1350-1375. Photograph by Anthony F. Kersting, 1980. © Anthony F. Kersting/ AKG Images

p.26 The Wife of Bath, illustration from *The Canterbury Tales*, by Geoffrey Chaucer, in the Ellesmere Manuscript, 1400-1410, unknown artist(s) and scribe, MS EL 26 C 9. Commons: The Huntington Library, San Marino, California

p.28 Ploughing scene, illustration to Psalm 91 in The Luttrell Psalter, unknown artist, c. 1325-1335. MS Add 42130, f.170. © The British Library Board. All Rights Reserved/Bridgeman Images

p.30 The Westminster Portrait of Richard III, 1390s; unknown artist. Westminster Abbey. Creative Commons, user: JRennocks, June 2021

p.32 The Wilton Diptych, c. 1395, unknown French or English artist. National Gallery NG4451. Commons: The Yorck Project

p.34 'Enclosure of a Recluse', illustration in The Clifford Pontifical, c.1400-1410, artist unknown. MS 079: Pontifical, f.96r. Reproduced by kind permission of the Parker Library, Corpus Christi College, Cambridge

p.36 'Revelations of St. Bridget of Sweden', unknown Italian artist, c.1400. ©Alamy

p.38 Panel 5c: 'The Beast makes war with the Saints', Great East Window, York Minster, John Thornton 1305-08 Reproduced by permission of ClearStory/Menace Productions © Chapter of York/York Glazier's Trust

p.40 Woodcut of a 15th-century choir, artist unknown from Der Spiegel des Menschlichen Lebens, Rodrigo Sánchez de Arévalo, Heinrich Steinhöwel (transl.), Augsburg, 1475-78. Public domain: www.archive.org

p.42 Wall painting of St. George and the Dragon, unknown artist, 1480-90, St. Cadoc's church, Llancarvan, Vale of Glamorgan, Wales. © Freespiritarchitecture/Alamy

Chapter Three (pp 44-63)

p.46 Detail from 'The Burning of the Archbishop of Canterbury, Thomas Cranmer, in the town ditch at Oxford', in Foxe's Book of Martyrs, John Foxe, 1563 © ClearStory/Menace Productions

p.48 The Darnley Portrait of Queen Elizabeth I, 1575; undated and unsigned portrait of Elizabeth I, British School. © ART Collection/Alamy

p.50 Detail from The Bacton Altar Cloth, creator(s) unknown, mid-16th c. Royal Collection Trust. © ClearStory/Menace Productions

p.52 William Byrd portrait, Italian line drawing, date and artist unknown. © Granger Historical Picture Archive/Alamy

p.54 The Penicuik Jewels, late c. 16th, believed to be the property of Mary, Queen of Scots: detail of a gold locket containing a portrait, believed to be that of Mary, Queen of Scots. National Museum of Scotland. © ClearStory/ Menace Productions

p.56 Detail from the Marian Hangings, Oxburgh Hall, created by Mary, Queen of Scots and Bess of Hardwick, 1569-85. © Alamy

p.60 Genesis, Chapter One. William Morgan Bible, 1588. Commons: National Library of Wales

p.62 Scene from Shakespeare's Othello, 'Il l'étouffe' (He smothers her). Plate 13 of Othello: 15 Sketches Drawn and Engraved by Théodore Chassériau.

Paris, 1844. Commons: Metropolitan Museum of Art, Accession No. 32.7.13, Harris Brisbane Dick Fund, 1932

Chapter Four (pp 64-83)
p.66 The Tulip Stairs, Queen's House, Greenwich. © Beatrice Hernandez via Flickr
p.68 Portrait of Philip Herbert, fourth Earl of Pembroke, and his family. Anton van Dyck, 1635. © Vidimages/Alamy
p.70 'English Protestantes striped naked', illustration by Wenceslaus Hollar in The Teares of Ireland, by James Cranford, 1642. Commons: National Library of Ireland (http://catalogue.nli.ie/Record/vtls000182170)
p.72 Samuel Cooper's portrait of Oliver Cromwell, based on the miniature of 1656. Reproduced by permission of ClearStory/Menace Productions. © Buccleuch Living Heritage Trust
p.74 'Satan Arousing The Rebel Angels', illustration by William Blake, 1808, to Milton's *Paradise Lost*. © Historica Graphica Collection/Heritage Images/Alamy
p.76 A flea, magnified illustration from Robert Hooke's *Micrographia*, 1655. Public Domain.
p.78 Detail from limewood carvings by Grinling Gibbons, 1692 in the Carved Room, Petworth House. © ClearStory/Menace Productions
p.79 Louis XIV gilt headboard, 17th century. www.frenchfarmhousefurniture.co.uk
p.80 'Concert (The Prodigal Son Among The Prostitutes)', Dirck van Baburen, © State Museum, Mainz/AKG Images
p.82 Dome of St. Paul's cross-section, engraving by Samuel Wale and John Gwynn, 1755 (for George, Prince of Wales). Commons, user: Bhoeble-commonswiki

Chapter Five (pp 84-103)
p.86 Harewood House engraving by J.D. Neale in *The Beauties of England and Wales*, Vol. XVI, by John Bigland, 1812. Public Domain: www.archive.org
p.88 Plate 1 of 'Marriage À La Mode,' engraving by Louis Gérard Scotin 1745, after William Hogarth, 1745. Rosenwald Collection 1944.5.11, National Gallery of Art, Washington. Commons
p.90 Printed extract from *A Modest Proposal* (3rd edition, p. 11) by Jonathan Swift, 1729. Public domain: www.archive.org
p.92 Anti-slavery medallion, produced by Josiah Wedgwood, modeller William Hackwood, ca. 1787. Commons: Metropolitan Museum of Art, New York. Accession No. 08242 Gift of Frederick Rathbone, 1908.
p.94 'The Anti-Saccharrites or John Bull and his family leaving off the use of

sugar', James Gillray, 1792. Reproduced by permission of ClearStory/Menace Productions. © British Museum/Bridgeman Images

p.96 Frontispiece engraving from *The Interesting Narrative of the Life of Olaudah Equiano or Gustavus Vassa, The African, Written by Himself*, 1794. United States Library of Congress, Prints and Photographs division. https://lccn.loc.gov/98501896. Public Domain

p.98 Robert Burns, engraving by A. H. Payne, ca. 1843. © Georgios Kollidas/Alamy.

p.100 'Mother of Feminism' statue to honour Mary Wollstonecraft, by Maggi Hambling. Newington Green, London, November 2020. © Reuters/Paul Childs/Alamy

p.102 '"Mr Bertram," said she, with a smile.' Illustration by Austin Dobson in Mansfield Park, by Jane Austen; Macmillan 1897. Commons: Flickr/BL

Chapter Six (pp 104-129)

p.106 'Rain, Steam and Speed – The Great Western Railway', J.M.W Turner, 1844 (first exhibited). National Gallery. © World History Archive/Alamy

p.108 'Cyfarthfa Ironworks Interior At Night', Penry Williams, 1825. Cyfarthfa Castle Museum. © Clearstory/Menace Productions

p.110 A homeless family. Engraving by unknown artist in Cassell's *Illustrated History of England*, Vol. VII. 1865. Public Domain: www.archive.org

p.112 'The Cotton Famine – Group of Mill Operatives at Manchester', unknown artist in *Illustrated London News*, Saturday 22nd November 1862. Public Domain: www.archive.org

p.114 Detail from St. Vincent Street Church, Glasgow, designed by Alexander Greek Thomson 1859. © Clearstory/Menace Productions

p.116 'King Arthur' (1874), photograph by Julia Margaret Cameron to accompany Tennyson's *Idylls of the King* (published 1874 and 1875). Commons: https://www.flickr.com/photos/preusmuseum/5332647056/

p.118 'Proserpine', Gabriel Dante Rossetti, 1874. Tate Britain. © Granger Historical Picture Archive/Alamy

p.120 William Morris wallpaper. Retrieved from www.wallpaperaccess.com

p.122 Frontispiece to Christina Rossetti's 'Goblin Market', engraved by Morris, Marshall, Faulkner & Co., after Gabriel Dante Rossetti, 1862. Commons: Metropolitan Museum of Art, Accession No. 37.58.1. Gift of Walter Hildberg, 1937.

p.124 'A Child's World', John Everett Millais, 1886; Lady Lever Art Gallery, Liverpool © Peter Barritt/Alamy; 'Bubbles', advertising print, J.F. Barratt/A & F Pears Ltd., 1888 Department of Engravings, Illustrations and Design, Accession No. E224-1942. Donated by Mr W.H. Keep. © The Victoria

and Albert Museum. [Both images reproduced by permission of ClearStory/Menace Productions]

p.126 Photographic portrait of Oscar Wilde by U.S photographer and lithographer Napoleon Sarony, 1882. Commons: United States Library of Congress Prints and Photographs Division, digital ID cph.3g07095.

p.128 'The Camden Town Murder', originally titled, 'What Shall We Do for the Rent?' Walter Sickert, 1908. Tate. © The Picture Art Collection/Alamy

Chapter Seven (pp 130-151)

p.132 Photographic portrait of William Butler Yeats by the U.S. photographer Alice Boughton, in *Irish Plays and Playwrights*, by Cornelius Weygand. Hougfhton Milfflin, 1913. Commons user: Jimregan

p.134 Charleston Farmhouse – © Lynn Hilton/Alamy

p.136 'To The Unknown British Soldier In France', William Orpen, 1923. © Imperial War Museums IWM Art 4438

p.138 1930s Poster advertising the Cunard White Star line and the Queen Mary. © Shawshots/Alamy

p.140 De la Warr Pavilion, Bexhill-on-Sea: the sea-facing frontage and the glass-enclosed staircase. Photograph by Leo Herbert Felton, 1935. From the archive of Sir Anthony Wakefield Cox. Reproduced by permission of ClearStory/Menace Productions. © RIBA Collections Ref. 55173/29 (H. Felton SCM11)

p.142 'Coal Searcher Going Home to Jarrow', 1937, photograph by Bill Brandt. Reproduced by permission of ClearStory/Menace Productions © Bill Brandt Archive, Ltd.

p.144 Still image featuring Roger Livesey as Major-General Clive Wynne-Candy in 'The Life and Death of Colonel Blimp', written, produced and directed by Michael Powell and Emeric Pressburger, 1943. General Film Distributors UK/United Artists US. © Moviestore Collection, Ltd./Alamy

p.146 'Three Studies For Figures At The Base Of A Crucifixion', Francis Bacon, 1944. Tate Collection NO6171. © Estate of Francis Bacon. All Rights Reserved, DACS 2022

p.148 Barbara Hepworth (1903–1975) at work on an abstract stone sculpture for the Dome of Discovery on London's South Bank for the Festival of Britain. *Picture Post* magazine, issue 5178, January 1951. Reproduced by permission of ClearStory/Menace Productions Photo by Haywood Magee/Picture Post © Hulton Archive/Getty Images.

p.150 'Crucifixion', F.N. Souza, 1959. Tate Collection T06776. © The Estate of F.N. Souza/DACS London, 2022

Chapter Eight (pp 152-175)

p.154 Poster advertising the UK cinematic release of Shelagh Delaney's 'A Taste of Honey', 1961. Reproduced by kind permission of Woodfall Film Productions. © A.F. Archive/Alamy.

p.156 Still of Philip Larkin from 'Monitor: Going Down Cemetery Road', BBC documentary, 1964. Reproduced by permission of ClearStory/Menace Productions © BBC Archive/Getty

p.158 'Notting Hill Couple', 1967, ClearStory/Menace Productions. © Charlie Philips

p.160 Cover design by Sir Peter Blake for *The Buddha of Suburbia* (1st ed.) by Hanif Kureishi. © Faber & Faber, 1990.

p.162 Cover design for *Trainspotting*, by Irvine Welsh, Vintage 1994. © Penguin Random House

p.164 Peace Walls, Belfast: (l) 'Bobby Sands' © DMc Photography/Alamy; (r) 'UFF member' © Paul Bucknall/Alamy; Save the Curlew mural, Lower Ormeau Cafe, Belfast. © emic (emicartist.com) for youthfornature.uk

p.166 Tracey Emin, 'Everyone I have ever slept with', © Tracy Emin. All Rights Reserved. DACS/Artimage, 2022

p.168 Cover design by Thomas Taylor for *Harry Potter and the Philosopher's Stone*, by J.K. Rowling (1st ed.), Bloomsbury, 1997. © Flab/Alamy

p.170 Michael Sheen as Christ in 'The Passion of Port Talbot', 2011. Reproduced by permission of ClearStory/Menace Productions © National Theatre of Wales

p.172 Stormzy at Glastonbury, 2019 Reproduced by permission of ClearStory/Menace Productions © BBC Archive/Getty

p.174 'Map of Nowhere' © Grayson Perry. Government art collection.